IMAGES
of America

NATIONAL
HARD CRAB DERBY

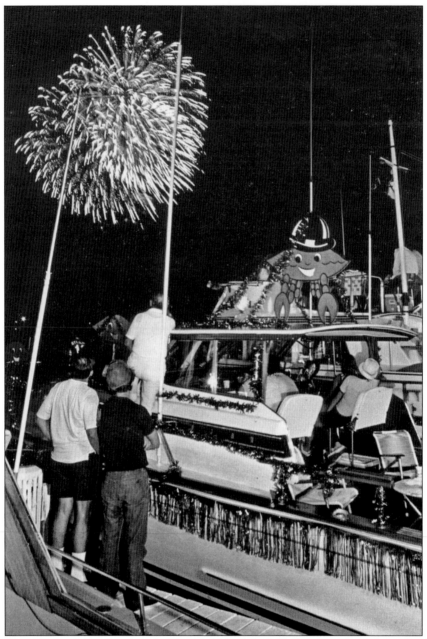

FIREWORKS. The traditional end to the National Hard Crab Derby, the annual fireworks display, has lit up the skies over Crisfield nearly every year since the mid-1950s. In this 1970s view, the shells exploded over Somers Cove Marina and the boat *A-Go-Go*, owned by Carlton Drewer. (Photograph by Scorchy Tawes, courtesy Crisfield Area Chamber of Commerce.)

ON THE COVER: Crab racing truly became competitive with the introduction of the Crab Cake Track in the early 1970s. The blue and yellow track allowed 50 crabs to be contained at a time in individual compartments and lowered onto the race board as a unit at the firing of the starter's gun. (Photograph by Scorchy Tawes, courtesy Crisfield Area Chamber of Commerce.)

IMAGES
of America

NATIONAL
HARD CRAB DERBY

Jason Rhodes

ARCADIA

Published by Arcadia Publishing
Charleston SC, Chicago IL, Portsmouth NH, San Francisco CA

Printed in the United States of America

Library of Congress Catalog Card Number: 2005938880

For all general information contact Arcadia Publishing at:
Telephone 843-853-2070
Fax 843-853-0044
E-mail sales@arcadiapublishing.com
For customer service and orders:
Toll-Free 1-888-313-2665

Visit us on the Internet at www.arcadiapublishing.com

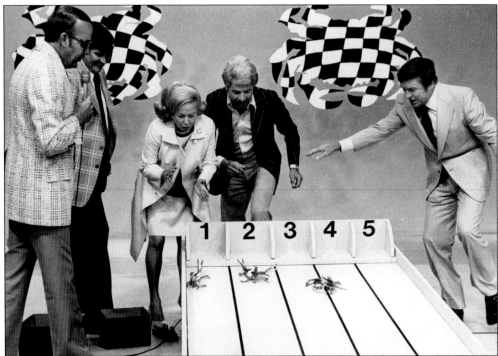

THE MIKE DOUGLAS SHOW. The derby was so popular by 1973 that CBS television host Mike Douglas wanted to show the races to the entire country. Pictured from left to right during that broadcast are derby announcer Harry T. Phoebus, derby chairman Larry Marshall, author Margaret Mitchell, comedian Dick Shawn, and Mike Douglas. (Courtesy Crisfield Area Chamber of Commerce.)

CONTENTS

ACKNOWLEDGMENTS

Undertaking any project of this size would be impossible without assistance from many individuals dedicated to preserving the history of the National Hard Crab Derby. The author extends thanks to the Crisfield Area Chamber of Commerce, Mary Nelson, and Norris "Scorchy" Tawes for their help in making this book a reality.

Pictures for which no credit is given are from the author's collection.

DEDICATION. This book is dedicated to the author's parents, Frank and Harriet Rhodes, seen here in 2005. They and hundreds of other volunteers have strived to keep the derby prosperous for more than half a century.

INTRODUCTION

Since its founding in 1889, Crisfield's hometown newspaper, the *Crisfield Times*, has been a force for change in the city. In the first half of the 20th century, the newspaper and its founder, Egbert L. Quinn, were instrumental in promoting local civic improvements, including road paving, public health and mercantile policies, and construction of a Pennsylvania Railroad passenger station.

In 1947, however, Quinn used his newspaper to advocate perhaps his most lasting contribution to Crisfield. With the help of *Times* editorial assistant Charles "Mac" McClenahan, he published the editorial "Let's Have a Hard Shell Crab Derby for Crisfield." Proposing the idea as a take-off on the Kentucky Derby to help promote the city's reputation as the crab capital of the East Coast, Quinn set the stage:

> Imagine, if you will, a well laid out course over which a dozen well-trained jimmy crabs are to race for peanuts or for real pelf. Visualize the time before the start of the race when the owner of each crab will be pumped for information about the crab's fitness, its pedigree, its chances of winning. Mark the anxious moments when the crabs are lined up, waiting for the signal to go! Hold your breath, people, as the crustaceans, eyeing each other, start what would be a memorable event in American—in world—history: a crab race.

The next summer, dozens of Crisfield residents braved a spell of foul weather to gather in front of the Crisfield Post Office at Fourth and Main Streets to witness the first National Hard Crab Derby. So successful was the event that in 1949 organizers had to move it to the local baseball diamond, Nelson Field, to provide bleacher seating for all the fans.

A larger newspaper, *The Baltimore Sun*, took interest in the derby. The *Sun's* promotion of the event caught the eye of Maryland governor William Preston Lane Jr., who presided over the second derby. The Chesapeake Bay Fishing Fair Association took note of the governor's interest in the race and the next year held the fishing fair in Crisfield in connection with the derby. From there, the event took off.

Organizers had toyed with adding events to complement the derby as early as 1949, when a crab picking contest, won by J. C. W. Tawes and Son Seafood employee Dorothy Young, was held. With the full attention of the state's fishing population focused on Crisfield in 1950, derby officials expanded the event into a citywide party. A beauty pageant was held to select a local girl to compete in the fishing fair's Queen of the Chesapeake contest. Jane Lawson was crowned Miss Crisfield. The next year, largely at Quinn's request, the beauty pageant returned with a new name: Miss Crustacean.

That year also marked the first Main Street Parade and arts and industrial fair held in connection with the Crab Derby. The fair was so successful it remained a part of the derby until the mid-1960s, when suitable indoor space could no longer be found. By that time, the derby had grown so popular, only outdoor venues were large enough to hold the crowds. The parade continues today.

More events were added. In 1960, Maryland governor and Crisfield native J. Millard Tawes invited his fellow state leaders to compete by starting the annual Governor's Cup Race. Governors throughout the United States still are encouraged to sponsor a crab in the annual contest, and most do. The crab-picking contest returned as a permanent annual fixture in 1963. Two years later, the annual crab cooking contest was added.

From 1963 to 1965, a Little Miss Crisfield Pageant was held. The pageant returned in 1972 with a new title: Little Miss Crustacean. Little Mr. Crustacean joined the royal family in 1977. The popular boat-docking contest began in 1971, and skiff racing was made a permanent addition in 1998, harkening to the popular powerboat races that drew derby visitors to Crisfield's shores in the 1950s.

All the while, visitors from across the state—even across the country—have joined in the festivities. Some have been famous: Sonny James, Tammy Wynette, Tommy James, and James A. Michener, to name a few. Most are just faces in the crowd. Each year, more than 10,000 of those faces make up the backdrop of the National Hard Crab Derby. Some come out of curiosity. Some make it an annual tradition. For most who grew up in Crisfield, the Crab Derby is a homecoming not to be missed.

People around the world have heard about the Crab Derby. Magazines from *National Geographic* to *The National Enquirer* have sung its praises. *USA Today* named it one of the nation's top 10 food-related festivals. The Food Network and Travel Channel both have filmed specials at the derby. CBS talk show hosts Mike Douglas and David Letterman have invited derby officials on their programs. A film crew from Germany even documented the crab races for European television.

What is it that keeps bringing them back? Is it the food? The people? The very idea of racing a crab? Whatever it is, most leave with memories they will not soon forget.

Images of America: *The National Hard Crab Derby* is dedicated to those memories, from the first derby in 1948 to those in the early 21st century. As the derby continues to grow in popularity, its past lives on through this volume.

One

NATIONAL
HARD CRAB DERBY

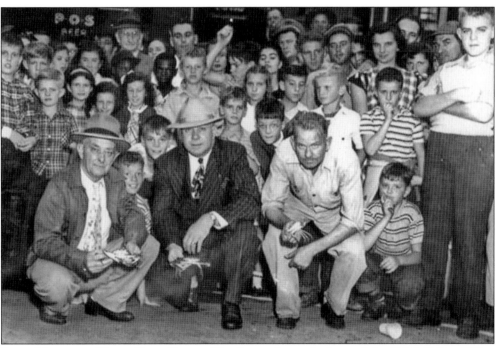

FIRST NATIONAL HARD CRAB DERBY. The first crab race in front of the Crisfield Post Office on Main Street in 1948 was an undisputed success. The crabs raced from the center of a chalk circle drawn in the middle of the street as hundreds of spectators waited for the winner, Scobie. Pictured in front from left to right are Rob Wharton, Wilbert Coulborne (holding Scobie), and Naugie Adams. (Photograph by Dick Moore, courtesy Scorchy Tawes.)

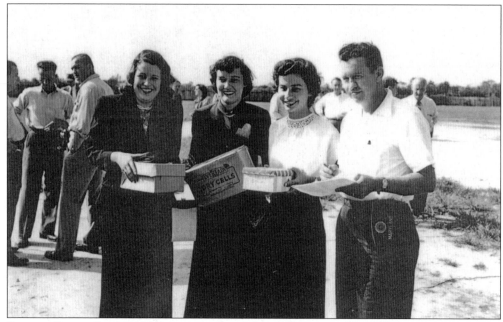

SECOND DERBY. In 1949, the races moved to Nelson Field, where these contestants awaited with their entries safely secured in cardboard boxes. The race format remained the same with crabs racing from the center of a chalk circle to its outer edge. This was a year of firsts for the derby: the first time the races were held at Nelson Field and the first year a program was produced for the event.

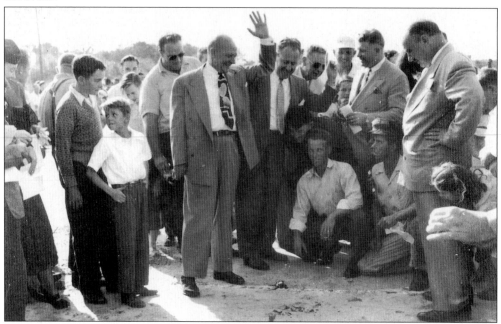

GOVERNOR LANE DECLARES THE WINNER. Thanks to publicity from the *Baltimore Sun*, word of the derby had reached Gov. William Preston Lane's office in Annapolis, and Maryland's top-elected officials made sure he was on hand for the second Hard Crab Derby. Governor Lane signaled that year's winner, Veedol, with a wave of his hand. (Courtesy Scorchy Tawes.)

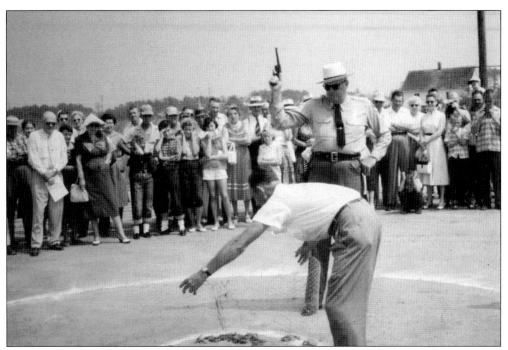

ON YOUR MARK. A Maryland state trooper prepared to start a crab race with a gunshot when this photograph was taken at an early derby. The derby official in the foreground waited for his cue to lift the wire cage that would set the crabs free for the race to the finish line.

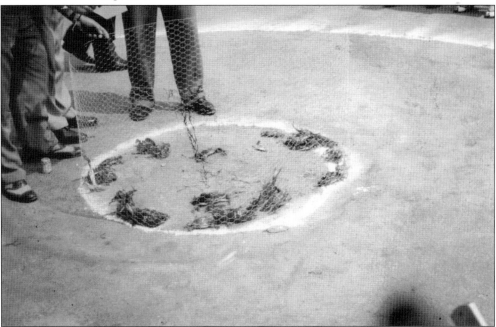

READY TO GO. Only 20 crabs ran in the first crab derbies, seen from the number of entrants during this early race at Nelson Field. For many years, those who raced crabs provided and trained their own. Most also gambled on the outcome of the race, spurred on by advertisements in the official program that encouraged them to bet on their favorite crustaceans.

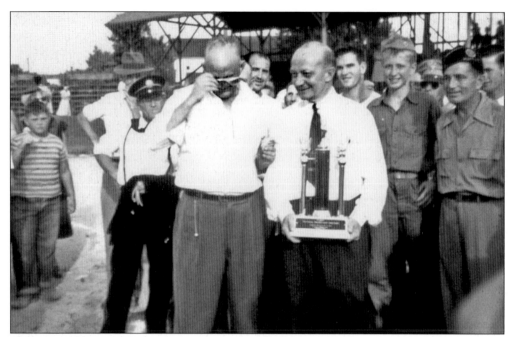

SUNPAPERS TROPHY. Governor Lane presented the winner of this early Crab Derby with the Sunpapers Trophy, sponsored for many years by the *Baltimore Sun*. The elaborate structure in the background comprises the bleachers of Nelson Field, where during baseball season and Crab Derby, fans could watch the respective sports in the comfort of shade.

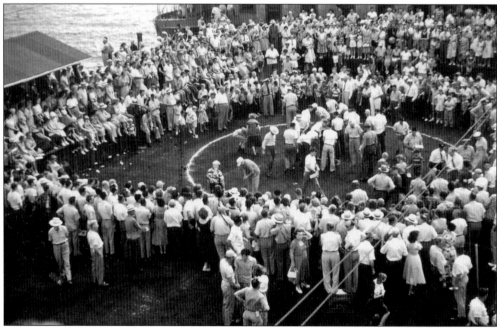

SIXTH CRAB DERBY. The races had moved to the Crisfield steamboat wharf by the time this photograph was taken in 1953 but continued to retain the circle format. The parent-teacher association of Crisfield Elementary School No. 3 held a special fund-raiser at the sixth Crab Derby, selling hot dogs and sodas from the large steamboat building in the background.

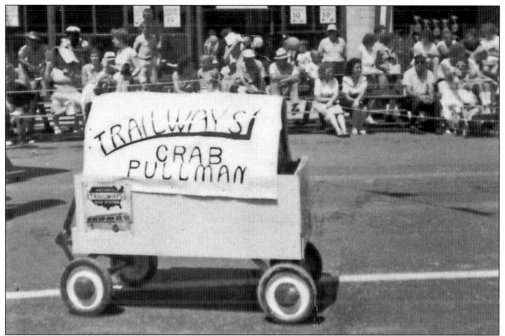

CRAB PULLMAN. The brainchild of longtime derby volunteer and Trailways bus driver Carlton Drewer, the crab pullman, mounted atop a child's wagon, provided an innovative way to deliver contestants to this early-1960s Crab Derby. In later years, volunteers paraded contestants around the race area in bushel baskets during a short ritual before the races began.

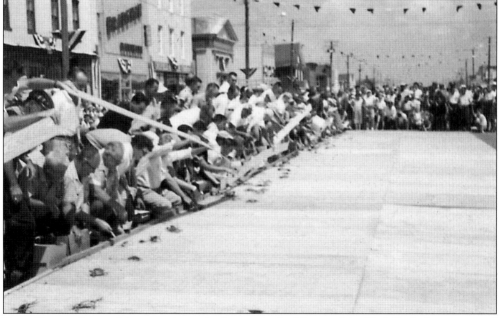

RACE BOARD. Some of the most dramatic changes in the history of the Crab Derby have occurred in the way the crabs race. Following a number of years of racing crabs from the inside of a chalk circle, derby officials devised a new method of racing: down a slanted board, as seen on West Main Street near the steamboat wharf in this photograph of the 17th Crab Derby in 1964.

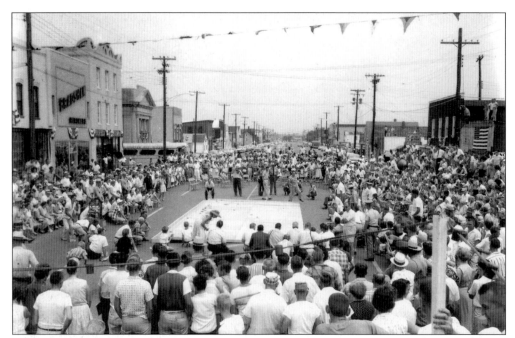

SURROUNDING THE RACERS. The race board moved to the middle of West Main Street when this 1960s photograph was taken, allowing spectators to surround the board as they had become accustomed to during the circle races. This practice was later outlawed when derby officials determined too much close-up confusion could stop some crabs dead in their tracks.

AMERICAN LEGION FIELD. The race board moved to American Legion Field at Brick Kiln in the late 1960s, providing spectators a place to watch the crabs from a suitable distance. The T-shirt worn by the derby volunteer stepping onto the race board was the first designed for the event. The same logo was used for many years before derby officials—and later the J. Millard Tawes Museum and Visitors Center—began offering a new design each year.

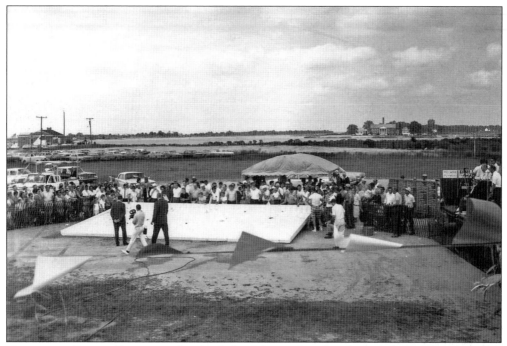

BEHIND THE BOARD. Competitors lined up behind the race board to cheer on their crabs at American Legion Field. The location gave spectators a view of two Crisfield landmarks: Stanley Cochrane American Legion Post 16 at left and Edward W. McCready Memorial Hospital at right.

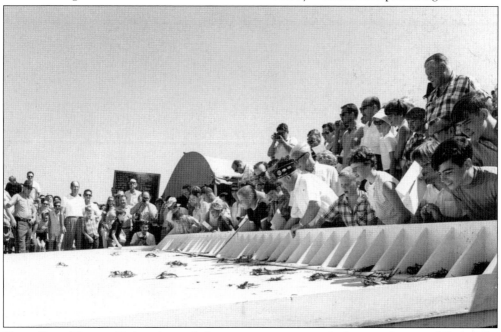

CRAB CAKE TRACK. Crab racing truly became competitive with the introduction of Crab Cake Track in the early 1970s. The blue and yellow track allowed 50 crabs to be contained at a time in individual compartments and lowered onto the race board as a unit at the firing of the starter's gun. (Photograph by Scorchy Tawes, courtesy Crisfield Area Chamber of Commerce.)

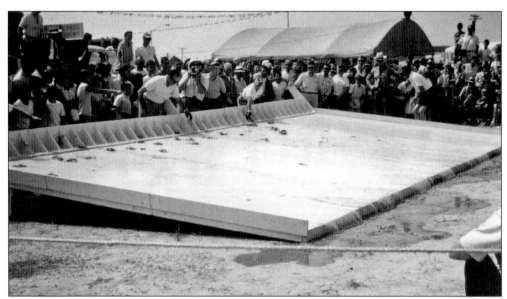

DOWN THE TRACK. The unique design of Crab Cake Track allowed crabs to race in a series of heats, the first-, second-, and third-place winners of each qualifying race pitted against each other to determine the overall winner. By allowing a greater number of entrants, the race's longtime sponsor, American Legion Stanley Cochrane Post 16, was able to increase the money brought in by the annual event.

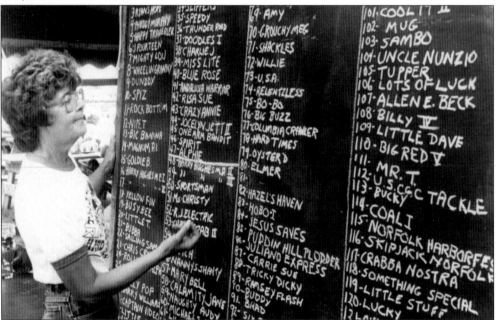

LISTING THE CRABS. Derby officials annually keep track of the hundreds of crabs entered in the race thanks to a large chalkboard. Each person entering a crab has the right to name the entry. Some traditionalists choose the same name every year, while others lean toward popular cartoon characters, movie stars, politicians, or just names made up on the spot, as seen in this early 1980s photograph featuring Miss Crustacean 1953 Marilyn Storus as the official tally keeper. (Photograph by Scorchy Tawes, courtesy Crisfield Area Chamber of Commerce.)

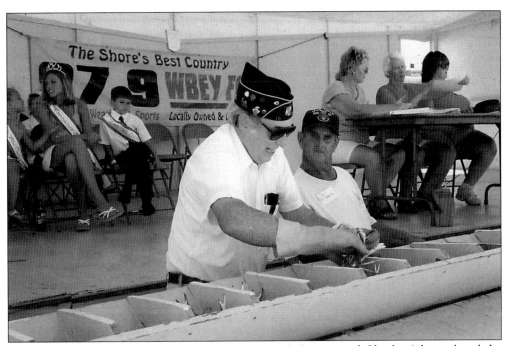

PREPARING THE ENTRANTS. Derby volunteers Dan O'Conner and Charlie Adams placed the crabs into the standby trough for the 59th annual race. Volunteers who have direct contact with the crabs often elect to wear gloves to protect their hands from the crustaceans' mighty claws.

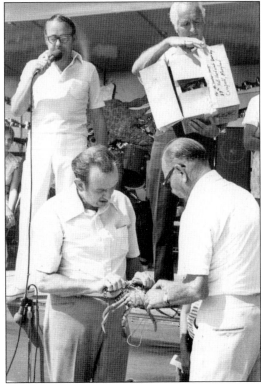

GOVERNOR'S CUP RACE. Begun in 1960 by Maryland governor and Crisfield native J. Millard Tawes, the annual Governor's Cup Race gives every state in the country a chance to participate in the crab derby by sponsoring a local crab or sending one of their own for entry. Pictured from left to right at the 1974 Governor's Cup race are longtime derby announcer Harry T. Phoebus Jr. with volunteers Bill "Ziggy" Holland, Carlton Drewer, and unidentified. (Photograph by Scorchy Tawes, courtesy Crisfield Area Chamber of Commerce.)

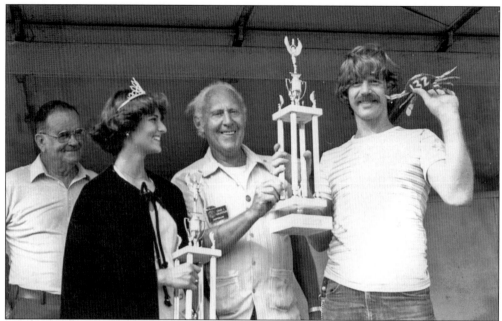

PRESENTING THE TROPHY. The unidentified owner of Slim Jim (right), the winner of the 1979 derby, met two dignitaries during his trophy presentation: Miss Crustacean Shaun Bradshaw and Maryland comptroller Louis L. Goldstein. The comptroller was a fixture of the derby for many years, visiting and passing out tokens imprinted with his longtime campaign slogan, "God bless you all real good." (Photograph by Scorchy Tawes, courtesy Crisfield Area Chamber of Commerce.)

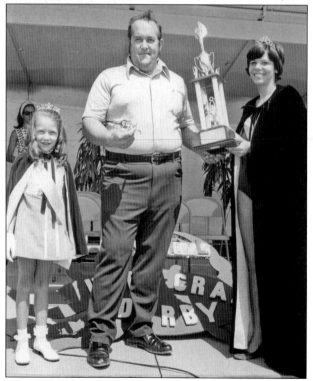

ON STAGE. Larry Tyler received the trophy for the 1972 derby from Miss Crustacean Ann Parks and Little Miss Crustacean Vonda Mason on the Showmobile stage. In use since the early 1970s, the Showmobile, a unique portable self-contained stage, has served as a backdrop for derby activities and other local events, including the annual Memorial Day Service at Crisfield Veterans Cemetery, for several decades.

Two

MISS CRUSTACEAN

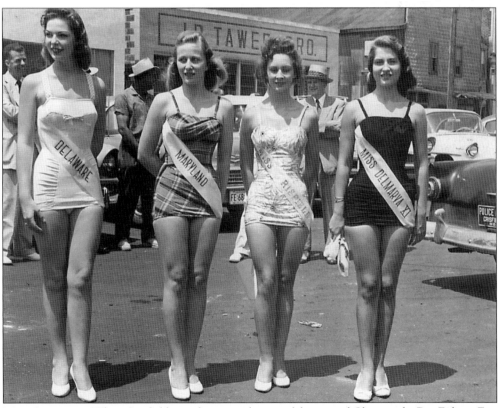

MISS CRISFIELD. When Crisfield was chosen as the site of the annual Chesapeake Bay Fishing Fair in 1950, the Crab Derby took on a whole new life as a statewide festival. One of the most popular new attractions was a pageant at the Crisfield Armory to choose a beauty queen to represent the city in the Queen of the Chesapeake Pageant. Jane Lawson was named Miss Crisfield, seen here third from left, with Miss Delaware, Miss Maryland, and Miss Delmarva 1950.

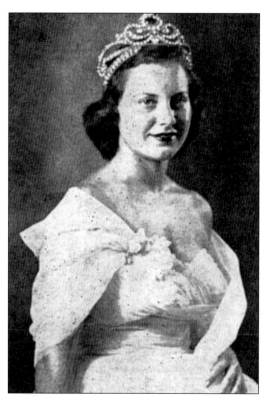

MISS CRUSTACEAN. Throughout Miss Crisfield's reign, newspaper editor Egbert L. Quinn of the *Crisfield Times* insisted on calling the beauty queen "Miss Crustacean," a title he thought better personified the Crab Derby. Officials changed the title to just that in 1951. It was bestowed for the first time upon Meta Justice, who went on to compete in the Miss America Pageant.

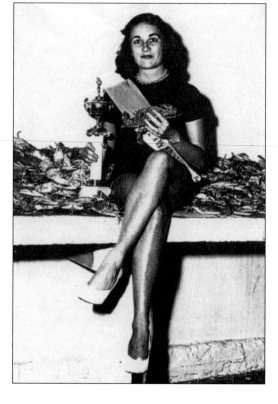

MISS CRUSTACEAN 1952. Emily Tilghman received the Miss Crustacean crown in 1952. This photograph was the first of many throughout the decades taken of the reigning Miss Crustacean to promote the derby in tourism advertisements. Most of the staged photographs also were used on the cover of derby programs through the early 1980s.

MISS CRUSTACEAN 1953 AND 1954. Miss Crustacean 1953 Marilyn Storus crowned her 1954 successor, Gayle Loreman (center), during the fifth Crab Derby beauty pageant. At right is first runner-up Dena Crockett. The American Legion Stanley Cochrane Post 16 Auxiliary sponsored Loreman in the contest.

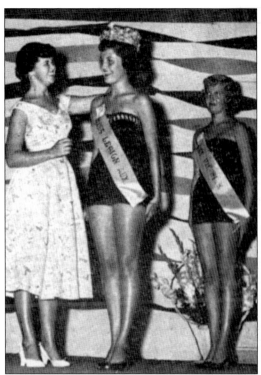

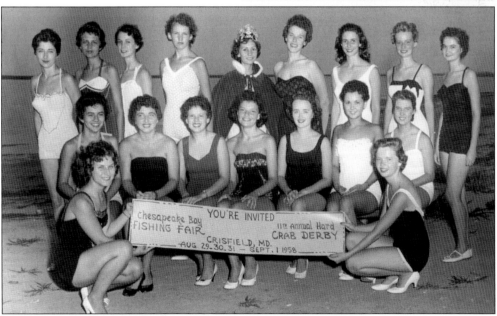

1958 CONTESTANTS. Chesapeake Bay Fishing Fair officials used this publicity photograph to invite anglers to the 11th National Hard Crab Derby in 1958. Pictured here from left to right are (first row) Faye Neal and Mary Riggin; (second row) Linda Lucy Nelson, Linda Laird, Barbara Bard, Deanna Blades, Pat Tawes, Sylvia Drewer, and Ann Sessions; (third row) Lois Ann Ward, Nellie Smith, Peggy Nelson, Linda Evans, Miss Crustacean 1957 Patsy Sterling, Peggy Murphy, Miss Crustacean 1958 Charlene Mosher, Janice Todd, and Norma Lou Daugherty.

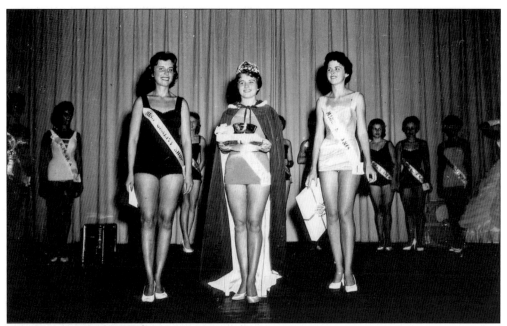

MISS CRUSTACEAN 1959. Becky Sterling was crowned Miss Crustacean 1959. Pictured with that year's Crab Derby queen are runners-up Sheila Foskey (left), sponsored by the Quality Shop, and Kay Maddox (right). Traditionally contestants participate in evening gown and swimsuit competitions. Finalists participate in a question-and-answer session as well.

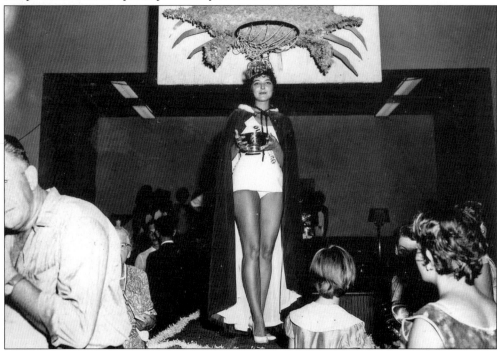

MISS CRUSTACEAN 1960. Georgia Rae Cullen accepted the Miss Crustacean title during the pageant at the Crisfield Armory. Volunteers decorated the backboard of the armory's basketball net with a giant crab to help set the spirit for the weekend.

MISS CRUSTACEAN 1961. Linda Sue Evans wore the Miss Crustacean crown in 1961. Pictured in the foreground is Miss Fire Department 1961.

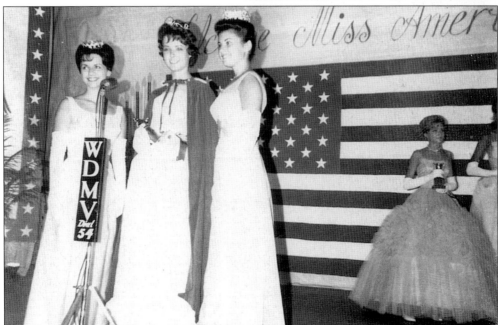

MISS AMERICA. From left to right, Miss Crustacean 1962 Vivian Ward and Miss Crustacean 1963 Christine Massey joined Miss America 1963 Jacquelyn Mayer on stage for a live broadcast by WDMV 540 AM, for many years the official radio station of the Crab Derby. Mayer participated in many of that year's Crab Derby events, including the Miss Crustacean Pageant and the Main Street Parade. Pictured at right in this view is 1963 Miss Crustacean contestant Vonnie Sterling.

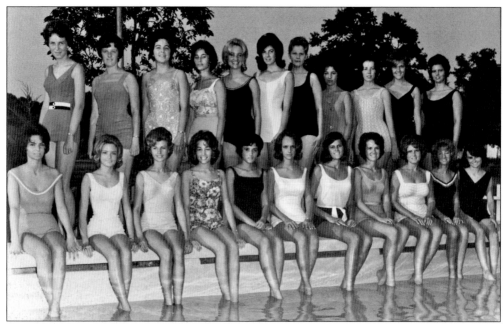

1964 CONTESTANTS. Contestants for the 1964 Miss Crustacean Pageant lined up at Granville's Pool for their photograph shoot. From left to right are (first row) Toni Evans, Vonnie Sterling, Nadina Wharton, Miss Crustacean 1964 Annette Tawes, Brenda Bozman, Gayle Hinman, Sally Davis, Toni Lewis, Ellen Smith, Bonnie Heath, and Sandra Tawes; (second row) Terry Pusey, Saundra Ruben, Helen Ward, Bonnie Hinman, Connie Carson, Carol Anne Daugherty, Nancy Tyler, Nevada Doyle, Virginia Mae Landon, unidentified, and Lynn Byrd.

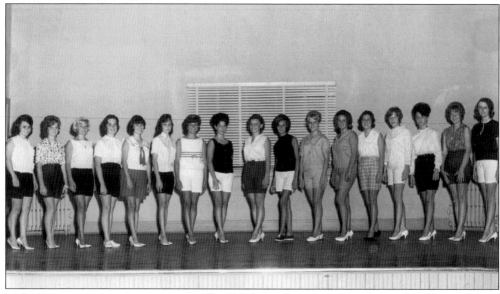

1965 CONTESTANTS. Contestants for the 1965 Miss Crustacean Pageant included, from left to right, Sandra Tawes, Susan Pusey, Mary Sue Wharton, unidentified, Nikki Dixon, Carrie Bowden, Miss Crustacean 1965 Barbara Ann Riggin, Nevada Doyle, Deborah Cox, Billie Rae Daugherty, unidentified, Terri Sue Milliner, Helen Ward, Melanie Howeth, Esther Tyler, Deborah Tyler, and Cindy Clayton.

Miss Crustacean 1966. Bonnie Adams captured the Miss Crustacean title in 1966, continuing the tradition of posing for the cover of the next year's Crab Derby program. Annual Miss Crustacean duties also have included appearing at local parades and events to promote the derby throughout the Delmarva Peninsula.

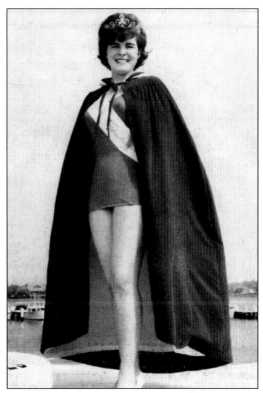

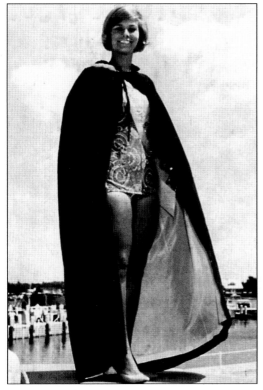

Miss Crustacean 1967. Ann Dykes won the judges' attention as Miss Crustacean 1967. In the 1960s, the new Somers Cove Marina offered the perfect nautical backdrop for the annual Miss Crustacean photograph. Opened in 1962, the marina has been the derby's home nearly each year since the early 1970s.

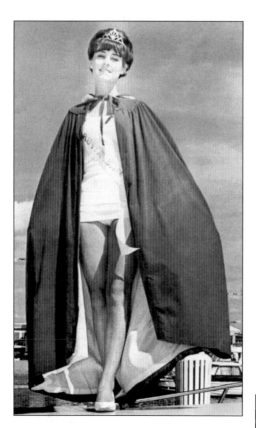

MISS CRUSTACEAN 1968. Tonya Ford continued the photograph tradition at Somers Cove Marina as Miss Crustacean 1968. Her picture appeared on the cover of the 1969 Crab Derby program.

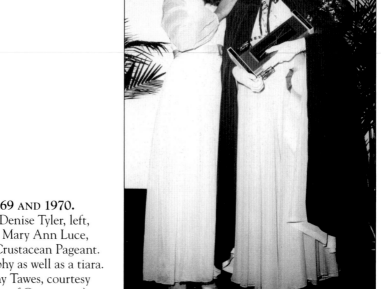

MISS CRUSTACEAN 1969 AND 1970. Miss Crustacean 1969 Denise Tyler, left, crowned her successor, Mary Ann Luce, during the 1970 Miss Crustacean Pageant. Awards included a trophy as well as a tiara. (Photograph by Scorchy Tawes, courtesy Crisfield Area Chamber of Commerce.)

MISS CRUSTACEAN 1971 AND 1972.
Miss Crustacean 1971 Gina Howeth, left, crowned her successor, Ann Parks, during the 1972 Miss Crustacean Pageant. Howeth handed down the title on the stage of the Showmobile during the outdoor pageant. (Photograph by Scorchy Tawes, courtesy Crisfield Area Chamber of Commerce.)

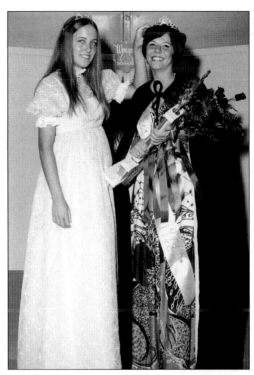

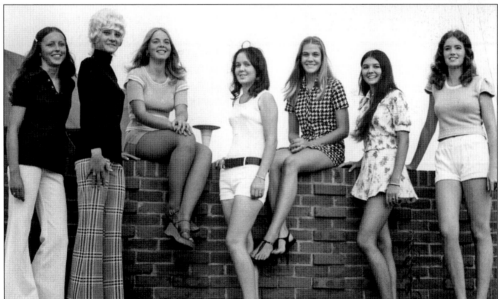

1973 CONTESTANTS. Miss Crustacean contestants for 1973 (and their sponsors) included, from left to right, Barbara Waller (Princess Anne Jaycees), Robin Carmine (Halterman's), Sandy Hastings (Maryland National Guard), Linda Tawes (Carvel Hall Cutlery), Miss Crustacean 1973 Lynn Crockett (Crisfield Rotary Club), Theresa Purnell (E&N Drive-In), and Susan Landon (Delmarva Power). Not pictured are contestants Linda Williamson (A&P), Debbie White (VFW Somerset Memorial Post 8274), Angela Custis (Rubberset Company), and Cecelia Owens (Windsor's Restaurant). (Photograph by Scorchy Tawes, courtesy Crisfield Area Chamber of Commerce.)

27

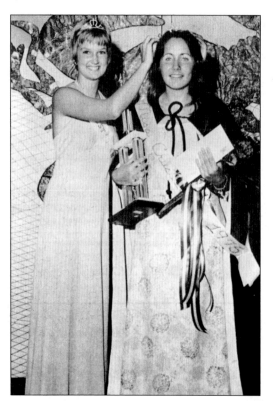

MISS CRUSTACEAN 1974 AND 1975.
Miss Crustacean 1974 Lynn Maddox, left,
crowned her successor, Vonnie Lynn Riggin,
during the 1975 Miss Crustacean Pageant.
The giant crab and net in the background
provided a festive backdrop for the occasion.
(Photograph by Scorchy Tawes, courtesy
Crisfield Area Chamber of Commerce.)

MISS CRUSTACEAN 1976. Sponsored by
Peninsula Bank, Pam Scott captured the
1976 Miss Crustacean title. Tickets for
the event were $2 and sold in advance at
Peyton's Pharmacy on Main Street and
the Bank of Somerset at Ward's Crossing.
(Photograph by Scorchy Tawes, courtesy
Crisfield Area Chamber of Commerce.)

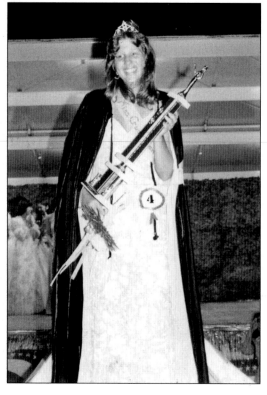

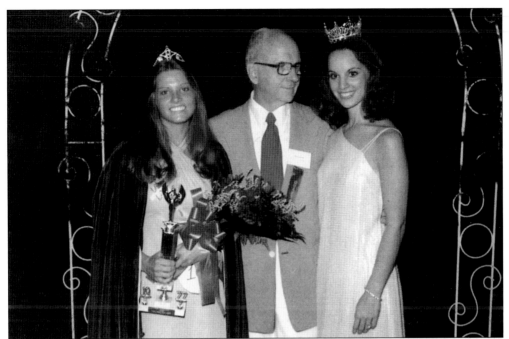

GOOD COMPANY. Miss Crustacean 1977 Lisa Riggin, left, was in good company as she accepted her crown, posing with author James A. Michener and Miss Maryland 1977 Barbara Jennings. Michener also was the grand marshal of that year's Main Street Parade. His book *Chesapeake* was based on Maryland's Eastern Shore. (Photograph by Scorchy Tawes, courtesy Crisfield Area Chamber of Commerce.)

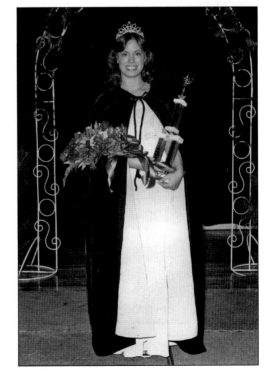

MISS CRUSTACEAN 1978. Lee Ann Parkinson won the title of Miss Crustacean 1978. In the 1970s, roses became part of the standard Miss Crustacean prize, along with the tiara, cape, and trophy. (Photograph by Scorchy Tawes, courtesy Crisfield Area Chamber of Commerce.)

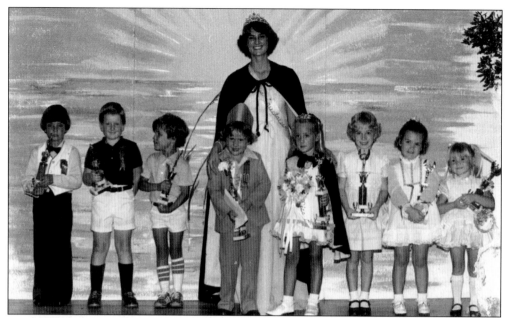

MISS CRUSTACEAN 1979. Shaun Bradshaw stood with winners of the 1980 Little Miss and Mr. Crustacean Pageant as one of her last official acts as the Crab Derby's goodwill ambassador. Pictured center in front of Bradshaw are Little Mr. Crustacean 1980 Brandon Britton and Little Miss Crustacean 1980 Kelly Wilmer. (Photograph by Scorchy Tawes, courtesy Crisfield Area Chamber of Commerce.)

1980 CONTESTANTS. Miss Crustacean contestants in 1980 included from left to right (first row) Keena Tyler, Mary Anne Evans, Mary Somers, Lara Ward, Teresa Gray, Karen Byrd, Karen Long, Anita Thomas, Valerie Wroten, Miss Crustacean 1981 Wendy Reese, and Anita Howeth; (second row) Teresa Justice, Bonnie Aswell, Susan Tawes, Peggy Jo Abbott, Natalie Evans, Virginia Purnell, Miss Crustacean 1982 Janet Wilson, Laurie Sterling, Bonnie Townsend, and Miss Crustacean 1980 Tammy Windsor. Not pictured are contestants Sherri Brittingham, Melissa Coons, Kandy Cullen, and Faye Hess. (Courtesy Crisfield Area Chamber of Commerce.)

MISS CRUSTACEAN 1983. Alice Hill, third from left, posed with her court following her victory at the 1983 Miss Crustacean Pageant. By then, prizes had grown to include a royal scepter for the annual queen to carry at official events. (Photograph by Scorchy Tawes, courtesy Crisfield Area Chamber of Commerce.)

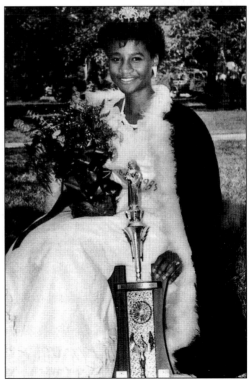

MISS CRUSTACEAN 1984. Joy Whittington won the Miss Crustacean crown in 1984. By the 1980s, the trophies for Miss Crustacean winners had evolved from the standard fare of the 1960s into intricate works of art. (Photograph by Scorchy Tawes, courtesy Crisfield Area Chamber of Commerce.)

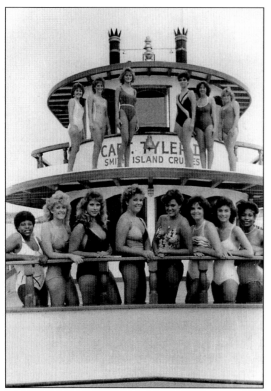

1985 CONTESTANTS. In one of the most intricately staged contestant photographs in the history of the Miss Crustacean Pageant, entrants lined the deck of the *Captain Tyler II* tour boat in this 1985 shot. Winner Sandy Insley is seen on the far left of the top deck. (Photograph by Scorchy Tawes, courtesy Crisfield Area Chamber of Commerce.)

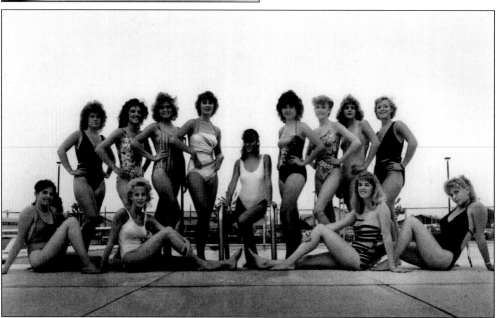

1986 CONTESTANTS. Those vying for the crown at the 1986 Miss Crustacean Pageant included, from left to right, (first row) Jennifer Gundling, Debbie Walls, Patricia O'Rourke, and Pam Ritter; (second row) Deedee Todd, Miss Crustacean 1986 Kathy Marshall, Keisha Tawes, Sharon Stiverson, Carol Reese, Maria Howard, Stephanie Dorsey, Lou Daugherty, and Jennifer Muir. (Photograph by Scorchy Tawes, courtesy Crisfield Area Chamber of Commerce.)

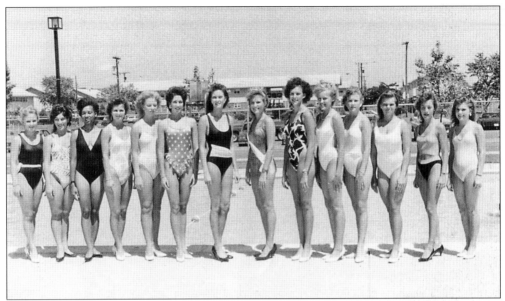

1988 CONTESTANTS. Girls taking the stage at the 1988 Miss Crustacean Pageant included, from left to right, Katie Byrd, Josie Rodriguez, Therisa McCready, Stacey Nelson, Sherry Workman, Cynthia Bell, Timley Swift, Miss Crustacean 1987 Mindie Sue Tingle, Angela Ballantine, Lisa Biles, Renee Ward, Julie Landon, Miss Crustacean 1988 Dawn Thomas, and Angela Brumley. Not pictured are contestants Renee Dize and Melissa Williamson. (Courtesy Crisfield Area Chamber of Commerce.)

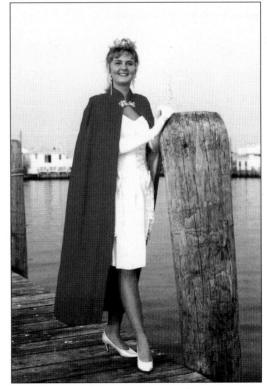

MISS CRUSTACEAN 1989. The Crisfield City Dock filled in for Somers Cove Marina as derby officials went back to the tradition of using maritime scenes as the backdrop of the official portrait when Robin Simpson received the Miss Crustacean title 1989. Simpson accepted the crown from Pam Martin when Martin stepped down from the position prior to the end of her reign. (Courtesy Crisfield Area Chamber of Commerce.)

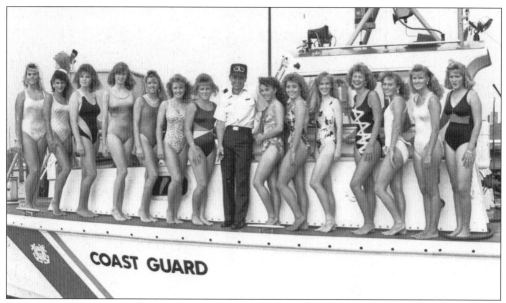

1990 CONTESTANTS. Those vying for the title in 1990 included, from left to right, Tonya Evans, Marsha Ozewecki, Katie Cooper, Amy Freeman, Laurie Harris, Miss Crustacean 1990 Melanie Lankford, Katie Byrd, Dana Syda, April Richardson, Jennifer Gabby, Gina Esley, Jill Dize, Andrea Atkins, and unidentified. Pictured with the contestants is a U.S. Coast Guardsman, representing the Coast Guard station in Crisfield. (Courtesy Crisfield Area Chamber of Commerce.)

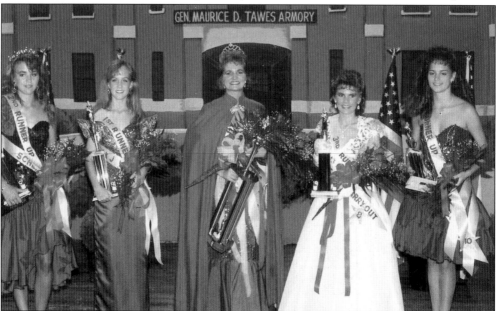

MISS CRUSTACEAN 1991. Stacey Nelson was crowned Miss Crustacean at the 1991 pageant, posing with her court in front of a large mural of Crisfield's Gen. Maurice D. Tawes Armory. Pictured from left to right are second runner-up Michelle Bloxom, first runner-up Jennifer Gabby, Nelson, third runner-up Angela Brumley, and fourth runner-up (and Miss Crustacean 1992) Amy Maddrix. Following Nelson's marriage prior to the end of her reign, Gabby accepted the Miss Crustacean title.

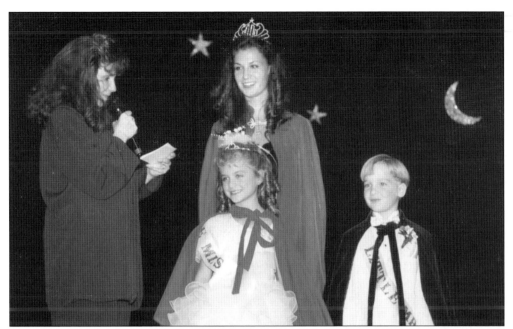

MISS CRUSTACEAN 1993. Shannon Heath fulfilled one of her final duties as Miss Crustacean 1993 by crowning Little Miss and Mr. Crustacean 1994 during the pageant at Crisfield High School. Pictured with Heath are 1994 winners Teresa Lynn Sterling and Christopher White. The announcer at left is unidentified.

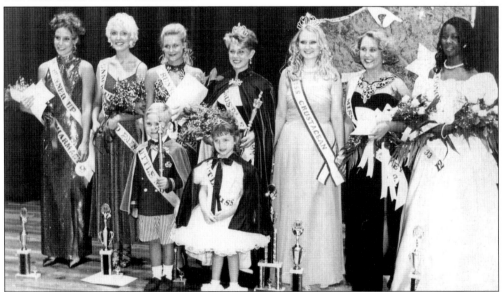

MISS CRUSTACEAN 1994 AND 1995. Miss Crustacean 1995 Sara Cross is perhaps the most famous beauty queen to hail from the Hard Crab Derby. Less than two months after her crowning, she appeared on the CBS talk show *Late Night* with David Letterman in a spoof of that year's Miss America Pageant. Pictured from left to right are (in front) Little Mr. and Miss Crustacean 1995 Adam Waller and Joscelyne Swift; (second row) 1995 court members Jennifer Lankford, Leah Blake, Dana Chamberlin, Cross, Miss Crustacean 1994 Ginger Parke, Amy Martini, and Christean Collins.

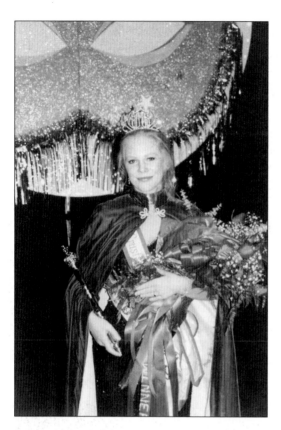

MISS CRUSTACEAN 1996. Dana Bullock was crowned Miss Crustacean 1996. The glittery mask behind her represents that year's Crab Derby theme: Mardi Gras.

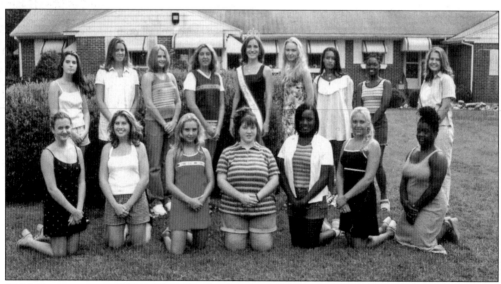

1998 CONTESTANTS. Taking the stage for the 1998 Miss Crustacean Pageant included, from left to right, (first row) Jenna Sterling, Kristen Cullen, Melissa Purnell, Mikki Justice, Jere Johnson, Miss Crustacean 1998 Tanya Briddell, and Na-Imah Matthews; (second row) Sara Barnes, Julie Carson, Heather White, Shaun Dize, Miss Crustacean 1997 Sara Widdowson, Jennifer Kenney, Danielle Tucker, Amber Tucker, and Krispen Parke.

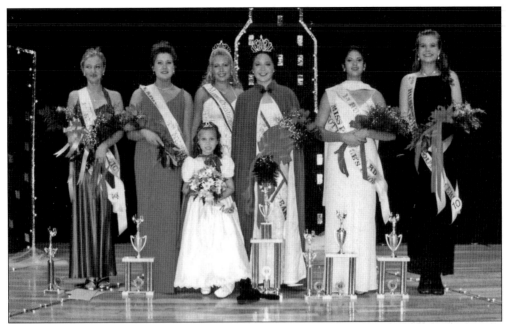

MISS CRUSTACEAN 1999. Jennifer Ward was named Miss Crustacean 1999. Pictured from left to right is that year's court: fourth runner-up Christina Byrd, third runner-up Christie Cox, Little Miss Crustacean 1999 Rachael Mrohs, Miss Crustacean 1998 Tanya Briddell, Ward, first runner-up Laquasha Bivens, and second runner-up Krispen Parke.

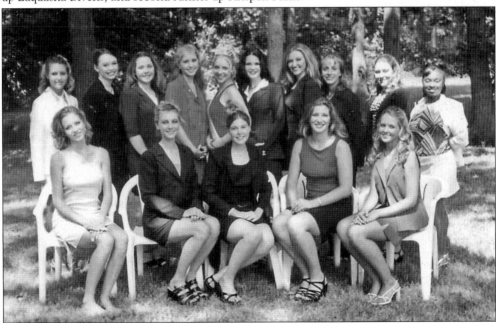

2001 CONTESTANTS. Taking the stage for the 2001 Miss Crustacean Pageant included, from left to right, (first row) Gabrielle Carlson, Bobbi Lynn Webb, Tracy Howard, Amber Hinman, and Miss Crustacean 2001 Ashley King; (second row) Jessica Morgan, Katy Smart, Tiffany Sterling, Allison Atkins, Miss Crustacean 2000 Kimberly Goepfert, Jamie Welch, Christina Byrd, Marlo Esley, Mary Thomas, and Chakita Crews. Not pictured is contestant Ciera Williams.

37

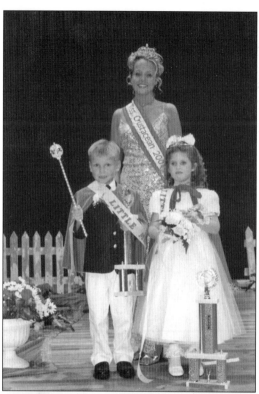

MISS CRUSTACEAN 2001. Miss Crustacean 2001 Ashley King celebrated the crowning of Little Mr. Crustacean 2002 Christopher Ford and Little Miss Crustacean 2002 Rachael Evans during the 2002 Little Miss and Mr. Crustacean Pageant at Crisfield High School.

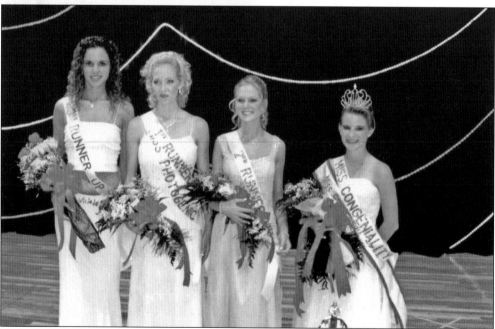

MISS CRUSTACEAN 2002. Miss Crustacean 2002 and Miss Congeniality Ginni Sue Lehman joined her court on stage following that year's pageant. Pictured from left to right are third runner-up Katrina Sterling, first runner-up and Miss Photogenic Gabrielle Carlson, second runner-up Jessica Shannahan, and Lehman.

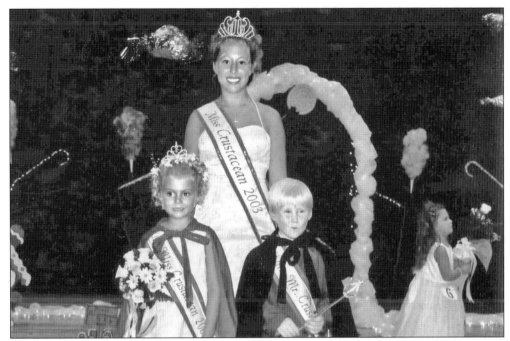

MISS CRUSTACEAN 2003. Jade Bentz was crowned Miss Crustacean 2003. She in turn crowned Little Miss Crustacean 2004 Hailie Brumley and Little Mr. Crustacean 2004 Jimmy Mansfield during the 2004 Little Miss and Mr. Crustacean Pageant at Crisfield High School.

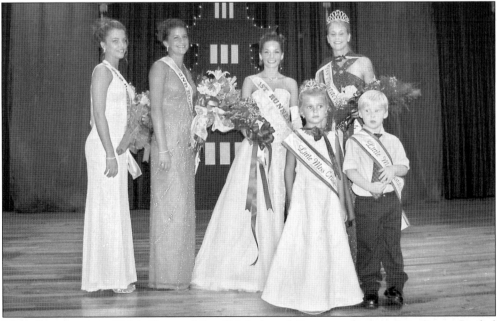

MISS CRUSTACEAN 2004. Former Miss Skipjack and Somerset County Fair Queen Rachel Horseman wore the Miss Crustacean crown in 2004. Pictured from left to right at that year's pageant are third runner-up and Miss Photogenic Keleigh Mrohs, second runner-up and Miss Congeniality Ashley Holland, first runner-up Elizabeth Swezc, Little Miss Crustacean 2004 Hailie Brumley, Horseman, and Little Mr. Crustacean 2004 Jimmy Mansfield.

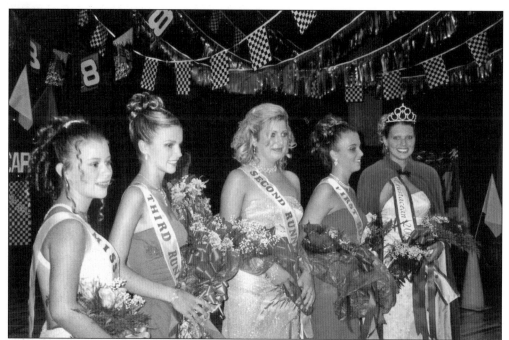

MISS CRUSTACEAN 2005. Kim Sterling was crowned Miss Crustacean 2005. Pictured from left to right are Miss Congeniality Brittany Mears, third runner-up Joscelyne Swift, second runner-up Ravan Marshall, first runner-up and Miss Photogenic Keleigh Mrohs, and Sterling.

1959 MISS CRUSTACEAN FLOAT. One of the most important duties of being Miss Crustacean is the honor of riding in the Main Street Parade, a staple of the National Hard Crab Derby since 1950. Here Miss Crustacean 1959 Becky Sterling rides atop a seashell-shaped throne on the annual float.

1966 MISS CRUSTACEAN FLOAT. The Crisfield Jaycees, which for many years hosted most of the derby weekend's non-race events, built this 1966 Miss Crustacean float, featuring Bonnie Adams and her court. Pictured in the background from left to right are unidentified, Adams, and Barbara Wharton. In the foreground is Nevada Doyle.

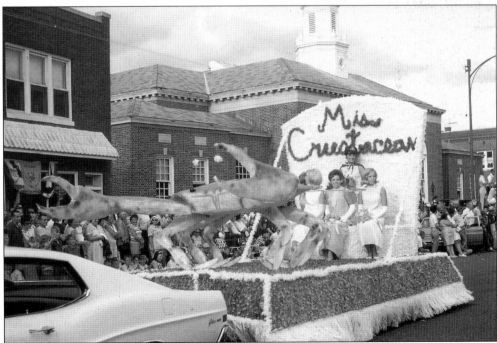

1968 MISS CRUSTACEAN FLOAT. The crab on the front said it all for this 1968 Miss Crustacean float. Passing the Crisfield Post Office in this shot, the float featured Tonya Ford and her court.

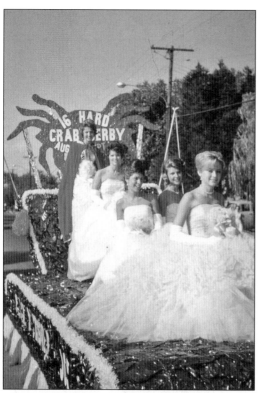

1963 MISS CRUSTACEAN FLOAT. Another Jaycees entry, this float featured Miss Crustacean 1963 Christine Massey and her court. Seen here, the float is lined up on Somerset Avenue, preparing to enter the main parade route on Main Street.

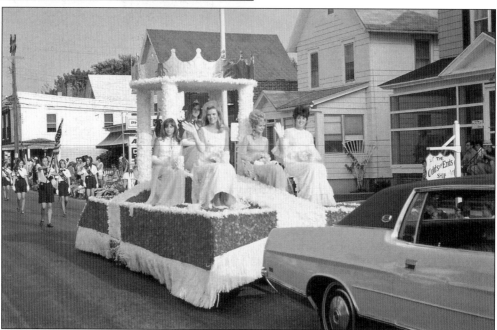

1971 MISS CRUSTACEAN FLOAT. Miss Crustacean 1971 Gina Howeth waved to crowds as her float passed the Odds and Ends Shop on Main Street during the 24th National Hard Crab Derby. Instead of a crab, the makers of this float opted to highlight the royalty aspect of the Miss Crustacean title.

Three

LITTLE MISS AND MR. CRUSTACEAN

LITTLE MISS CRUSTACEAN 1972. The idea of a Crab Derby beauty pageant for younger girls first caught on in 1963, when Debbie White was named the first Little Miss Crisfield. Patti Hall wore the crown in 1964, followed by Valerie Balderson in 1965. The pageant was discontinued until 1972, when the title was changed to Little Miss Crustacean. Vonda Mason, seen here with Miss Crustacean 1972 Ann Parks, was the first girl to earn that new title. (Photograph by Scorchy Tawes, courtesy Crisfield Area Chamber of Commerce.)

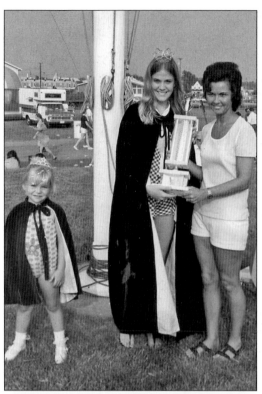

LITTLE MISS CRUSTACEAN 1973. Anita Kay Evans (left) wore the Little Miss crown in 1973. Pictured with her are Miss Crustacean 1973 Lynn Crockett (center) and trophy winner Sylvia Drewer. (Photograph by Scorchy Tawes, courtesy Crisfield Area Chamber of Commerce.)

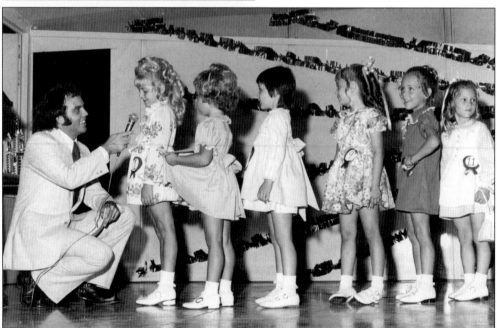

1974 FINALISTS. Host Jeff Hart interviewed finalists during the 1974 Little Miss Crustacean Pageant on the Showmobile stage. Pictured with Hart from left to right are Lou Daugherty, unidentified, Little Miss Crustacean 1974 Christy Emely, and three unidentified girls. (Photograph by Scorchy Tawes, courtesy Crisfield Area Chamber of Commerce.)

LITTLE MISS CRUSTACEAN 1975.
Col. David Levitt, winner of the
1975 World's Crabbiest Boss contest,
congratulated Little Miss Crustacean
1975 Ellen Scott as Little Miss
Crustacean 1974 Christy Emely
looked on. Derby officials held the
Crabbiest Boss contest for several
years from the late 1960s through the
mid-1970s. (Photograph by Scorchy
Tawes, courtesy Crisfield Area
Chamber of Commerce.)

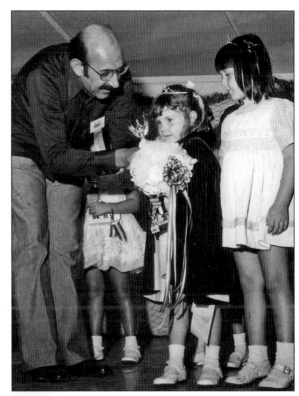

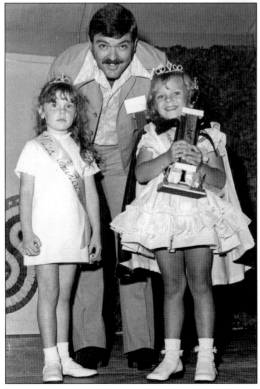

LITTLE MISS CRUSTACEAN 1976. The
Coca-Cola Bottling Company of Salisbury
sponsored the 1976 Little Miss Crustacean
Pageant. Pictured from left to right are
Little Miss Crustacean 1975 Ellen Scott,
Coca-Cola general manager Buddy
Dauphanis, and Little Miss Crustacean
1976 Julie Landon. (Photograph by
Scorchy Tawes, courtesy Crisfield Area
Chamber of Commerce.)

LITTLE MR. CRUSTACEAN ARRIVES. The concept of equality was alive in Crisfield in 1977 when derby officials added a Little Mr. Crustacean title to its mix of awards. Contestants in the inaugural contest included, from left to right, (first row) Gary Stewart, Gary Hinman, and Jamie Payne; (second row) Erik Emely, Rudy Hancock, Heath Carman, and Sparky Ward. (Photograph by Scorchy Tawes, courtesy Crisfield Area Chamber of Commerce.)

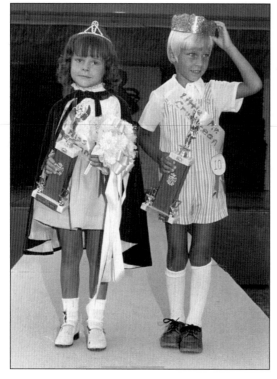

FIRST LITTLE MR. CRUSTACEAN. Little Mr. Crustacean 1977 Jamie Sterling joined Little Miss Crustacean 1977 Becky Tyler as the first male in the Crustacean kingdom. The pageant has continued annually as a coed event ever since. (Photograph by Scorchy Tawes, courtesy Crisfield Area Chamber of Commerce.)

1978 CONTESTANTS. Vying for the 1978 Little Miss and Mr. Crustacean titles were, from left to right, (first row) Candy Simmons, Tammy Pruitt, Angela Brumley, Amy Webb, and Laura Pool; (second row) Shawna Garrett, Christine Dennis, Rachel Horsey, Jeana Jones, Amy Maddrix, and Traci Olah; (third row) Brian Wroten, Lennie White, Alan Ford, Michael Knierim, Heath Carman, John Hill, Joey Paden, Chuckie Strobel, Clint Sterling, and Alfred Tuttle. (Photograph by Scorchy Tawes, courtesy Crisfield Area Chamber of Commerce.)

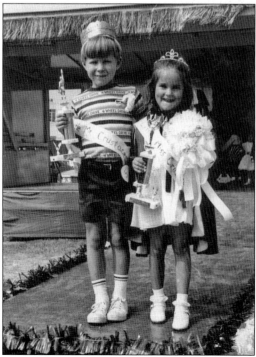

LITTLE MISS AND MR. 1978. Little Mr. Crustacean 1978 Alfred Tuttle and Little Miss Crustacean 1978 Amy Maddrix took their bows on the Showmobile stage following their victories. In 1992, Maddrix went on to become the first Little Miss Crustacean to grow up to win the Miss Crustacean Pageant as a teenager. (Photograph by Scorchy Tawes, courtesy Crisfield Area Chamber of Commerce.)

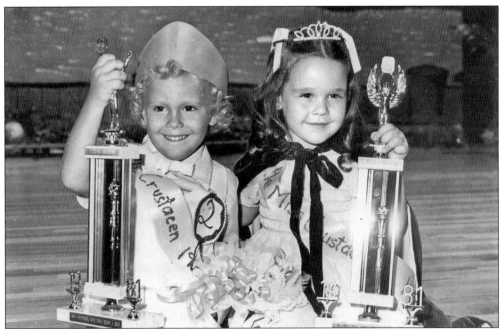

LITTLE MISS AND MR. 1981. Little Mr. Crustacean 1981 Ryan Sterling and Little Miss Crustacean 1981 Ashley Evans showed their trophies to the camera following their crowning during the pageant at Crisfield High School. (Photograph by Scorchy Tawes, courtesy Crisfield Area Chamber of Commerce.)

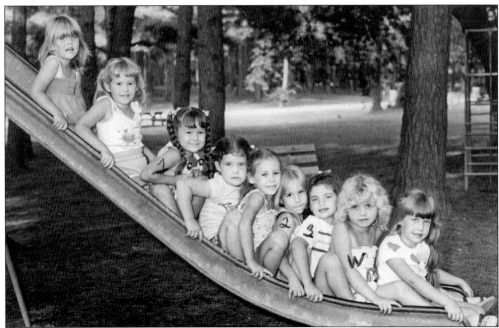

1982 CONTESTANTS. Little Miss Crustacean contestants in 1982 posed on the sliding board at Janes Island State Park. They included, from left to right, two unidentified contestants, Stacey Vaughn, Olivia Tyler, three unidentified contestants, Little Miss Crustacean 1982 Tonya Pendry, and unidentified. (Photograph by Scorchy Tawes, courtesy Crisfield Area Chamber of Commerce.)

1984 CONTESTANTS. Little Miss Crustacean contestants in 1984 showed their state spirit by posing with a Maryland flag. Barbara Bonneville won that year's pageant. Other contestants included Jennifer Lankford, third from the left in the top row, and Olivia Tyler at the bottom left. (Photograph by Scorchy Tawes, courtesy Crisfield Area Chamber of Commerce.)

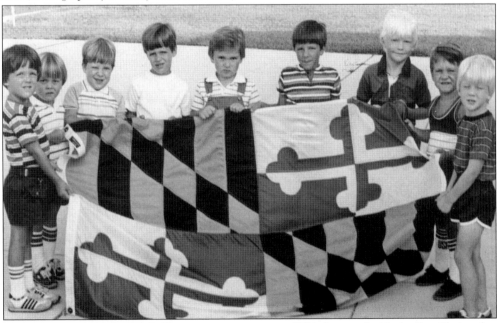

1984 CONTESTANTS. Little Mr. Crustacean contestants in 1984 also posed with the flag. Christopher Byrd was that year's winner. Contestants included, from left to right, Kris Nelson, Bobby Hill, unidentified, David Sterling, unidentified, Troy Schultz, Kris Cullen, unidentified, and Gary Cullen. (Photograph by Scorchy Tawes, courtesy Crisfield Area Chamber of Commerce.)

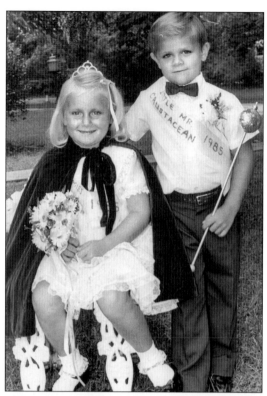

LITTLE MISS AND MR. 1985. Little Miss Crustacean 1985 Tiffany Wroten and Little Mr. Crustacean 1985 Shayne Jones posed for an official portrait following that year's pageant. Traditionally Little Miss and Mr. Crustacean contestants compete in a talent competition. Finalists participate in a question-and-answer session as well. (Photograph by Scorchy Tawes, courtesy Crisfield Area Chamber of Commerce.)

1986 CONTESTANTS. Those vying for the title of Little Miss Crustacean 1986 included, from left to right, Karen Landon, Chevonne Cuff, Kelly Thomas, Carolyn Bowland, Tanya Briddell, Jill Price, Shelly Evans, Elizabeth Davis, Heather Evans, and Shaun Dize. The Somers Cove Marina swimming pool served as the backdrop for their group picture. (Photograph by Scorchy Tawes, courtesy Crisfield Area Chamber of Commerce.)

1986 CONTESTANTS. Those vying for the title of Little Mr. Crustacean 1986 included, from left to right, Shawn Crockett, David Gebo, Justin Hoffman, Clifton Taylor IV, Ray Somers Jr., Reggie Sterling Jr., Timmy Linton, William Patterson, and Jamie Ford. (Photograph by Scorchy Tawes, courtesy Crisfield Area Chamber of Commerce.)

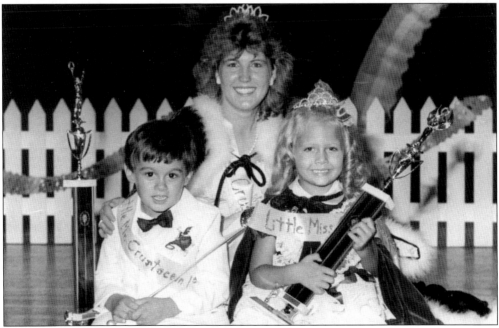

CRUSTACEAN ROYALTY. Miss Crustacean 1985 Sandy Insley congratulated Little Mr. Crustacean 1986 Timmy Linton and Little Miss Crustacean 1986 Tanya Briddell. Like Amy Maddrix nine years before, Briddell grew up to become Miss Crustacean as a teenager in 1999. (Photograph by Scorchy Tawes, courtesy Crisfield Area Chamber of Commerce.)

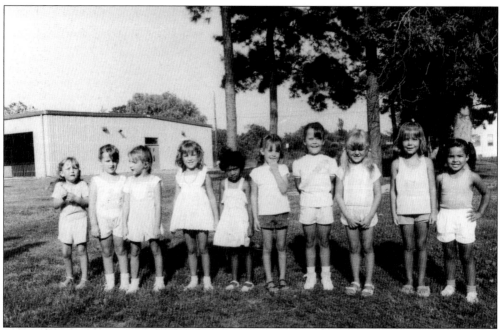

1987 CONTESTANTS. Little Miss Crustacean 1987 Nora Lee Smith, fourth from left, posed with contestants in that year's pageant. Most of the contestants in each year's pageant were familiar with one another from school, so group photographs like this one often were not awkward for the children.

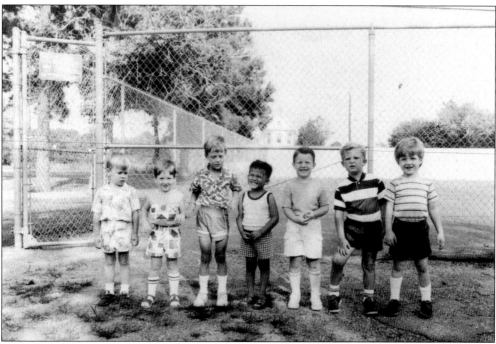

1987 CONTESTANTS. Little Mr. Crustacean 1987 Evan Ward, second from left, posed with his fellow contestants prior to that year's pageant. Published in local newspapers and often in the Crab Derby program, the group photograph is a Crab Derby tradition.

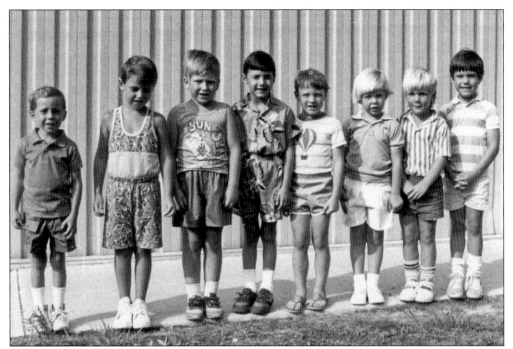

1988 CONTESTANTS. Those vying for the 1988 Little Mr. Crustacean crown included, from left to right, David Gebo, Steve Abbott, Russell Harrison, Jimmy Bowen, Joe Haase, Jeremy Ward, Jason Shaffer, and Corey Holland.

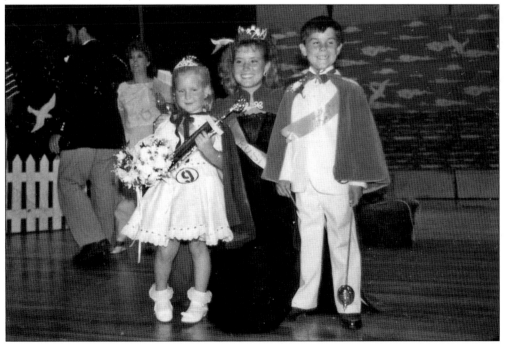

LITTLE MISS AND MR. 1988. From left to right, Little Miss Crustacean 1988 Sarah Mae Caldwell, Miss Crustacean 1987 Mindy Sue Tingle, and Little Mr. Crustacean 1988 posed in front of a seabird mural following the 1988 Little Miss and Mr. Crustacean Pageant.

1990 CONTESTANTS. Shannon Thomas was crowned Little Miss Crustacean 1990. Before the pageant, contestants posed for the annual group photograph at Somers Cove Marina. Contestants that year included Tonya Abbott, fourth from the left.

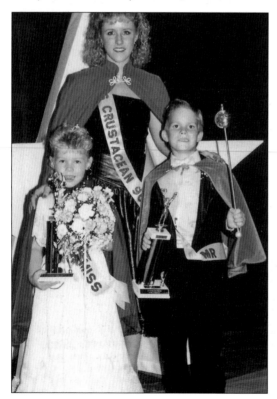

LITTLE MISS AND MR. 1991. Miss Crustacean 1990 Melanie Lankford posed with Little Miss Crustacean 1991 Randi Daugherty and Little Mr. Crustacean 1991 Charles Betts. The fact that both that year's winners lived on the same street in Crisfield's Down Neck section left many proclaiming that the pageant marked a big night for Johnson Creek Road.

1992 CONTESTANTS. Girls competing for the 1992 Little Miss Crustacean title included, from left to right, Jackie Sterling, Mindy Ward, Traci Kraft, Ericka Evans, Colby Bradshaw, Sara Grosky, Mary Lou Taylor, Little Miss Crustacean 1992 Ginni Sue Lehman, Kimberly Sterling, and Jade Bentz. Lehman, Sterling, and Bentz went on to be crowned Miss Crustacean in their teens.

1992 CONTESTANTS. Boys vying for the 1992 Little Mr. Crustacean crown included, from left to right, Jimmy Hinman, Brandon Taylor, Little Mr. Crustacean 1992 Robbie Lee, Robbie Colflesh, Lee Long, Daniel Diggs, and Travis Whittington.

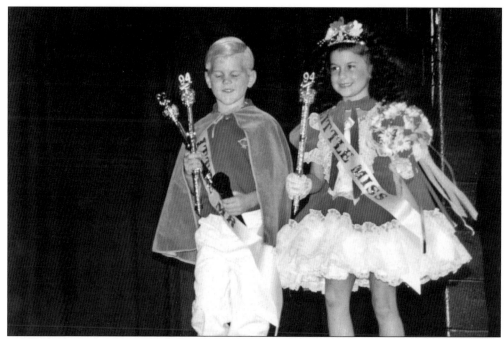

LITTLE MISS AND MR. 1994. The scepters on this pair make their reigning year difficult to mistake. Little Mr. Crustacean 1994 Christopher White and Little Miss Crustacean 1994 Ashley Holland took their bows on the Crisfield High School auditorium stage following their victories at that year's pageant.

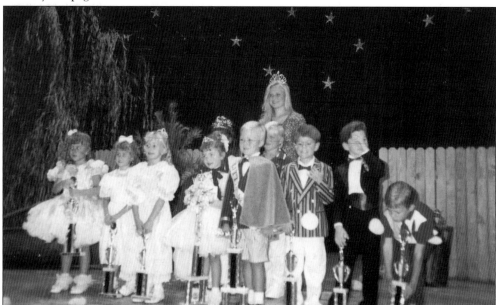

LITTLE MISS AND MR. 1995. Little Miss Crustacean 1995 Joscelyne Swift and Little Mr. Crustacean 1995 Adam Waller, in the foreground, stood with their court and Miss Crustacean 1994 Ginger Parke following the 1995 Little Miss and Mr. Crustacean Pageant. At the end of their reign, most Miss Crustaceans list attending events with their younger counterparts as one of the most enjoyable perks of the title.

1996 CONTESTANTS. Girls vying for the 1996 Little Miss Crustacean crown included, from left to right, (first row) Samantha Hoover, Shirlee Brown, Anna Hinman, Brittany Hoffman, and Megan Dize; (second row) Hailey Corbin, Kyle Bradshaw, Amanda Howard, Victoria White, and Brittany Wheatley. Little Miss Crustacean 1995 Joscelyn Swift, second row far right, joined them for the photograph.

1996 CONTESTANTS. Boys competing for the 1996 Little Mr. Crustacean title included, from left to right, (first row) Darren Parkinson, Patrick Swift, Kyle Wooster, Eric Schauffert, and Wesley Ward; (second row) Aaron "Bud" Applegate, Therman "Trey" Tyler III, Chris Goldsborough, and Ronald Sterling. Little Mr. Crustacean 1995 Adam Waller, second row far right, joined them for the photograph.

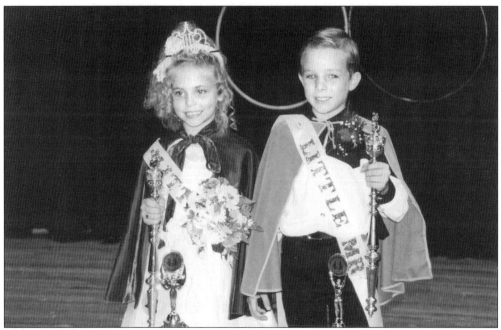

LITTLE MISS AND MR. 1996. Little Miss Crustacean 1996 Hailey Corbin and Little Mr. Crustacean 1996 Aaron "Bud" Applegate posed following their crowning that August. The circle behind them is part of the evening's Olympics décor, which included multi-colored hula hoops arranged in the shape of the Olympic rings.

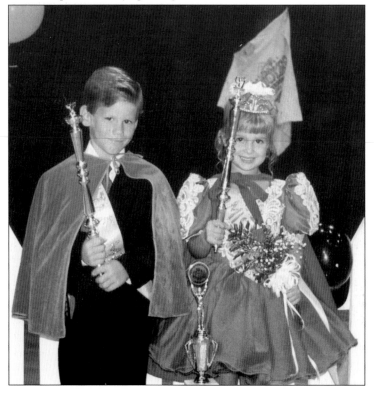

LITTLE MISS AND MR. 1997. Little Mr. Crustacean 1997 Andy Brice and Little Miss Crustacean 1997 Whitney Marshall smiled for the cameras moments after being crowned Crustacean royalty. That year, they reigned over the 50th National Hard Crab Derby, one of the largest celebrations in Crisfield's history.

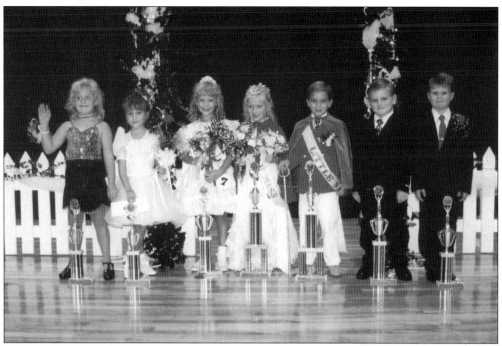

LITTLE MISS AND MR. 1998. The Little Miss and Mr. Crustacean court for 1998 included, from left to right, Myra Betz, Katelyn Howard, Elizabeth Long, Little Miss Crustacean 1998 Elle Hinman, Little Mr. Crustacean 1998 Zachary Long, Brandon Kitching, and Dylan Wooster.

1999 CONTESTANTS. Little Mr. Crustacean contestants for 1999 included, from left to right, Cody Holland, Kenny Sneade, Michael Forbush, Jordan Corbin, Ryan Swift, J. D. East, David Ross, Michael Mears, and Kenneth Byrd, set against the backdrop of the J. Millard Tawes Museum and Visitors Center. Not pictured was Little Mr. Crustacean 1999 Stephen Harrison.

1999 CONTESTANTS. Little Miss Crustacean contestants for 1999 standing at Somers Cove Marina included, from left to right, Jocelyn Colbert, Kayla Howard, Nicole Bishop, Little Miss Crustacean 1999 Rachael Mrohs, Brittany Coiro, Katelyn Howard, Danielle Catlin, and Patrice Ward.

LITTLE MISS AND MR. 2001. The Little Miss and Mr. Crustacean court for 2001 included, from left to right, third runner-up India Whitehead, first runner-up Kelli Hinman, Little Miss Crustacean 2001 Amy Wigglesworth, Little Mr. Crustacean 2001 Joshua Parkinson, third runner-up David Holland, and first runner-up Andrew Marsh.

Four

CRAB PICKING AND COOKING

CRAB-PICKING CONTEST. One of the highlights at most National Hard Crab Derby celebrations is the annual crab-picking contest. A part of the derby since 1963, it pits local—and sometimes non-local—crab pickers against one another in a test of skill to see who can pick the most crab meat in 15 minutes.

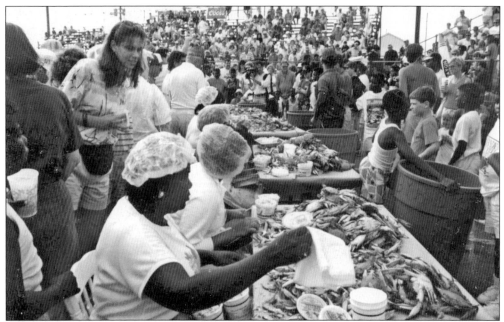

1989 CONTEST. Pickers along the tables at this competition were trying to break the record set in 1975 by Betty Lou Middleton: 4.97 pounds. Though no competitor has matched that weight since, contestants keep reaching for that goal. In more recent years, pickers also have sought to rack up enough wins to break the record by "Hurricane" Hazel Cropper, who won the 1989 competition and nine more between then and 2000.

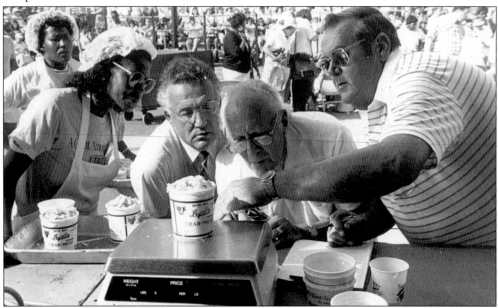

WEIGHING IN. Crab-picking judges balanced the scales for the 1988 contest, won by Joyce Fitchett with 3.7 pounds. Following the contest, spectators have the opportunity to purchase the freshly picked meat at market price. Many jump at the opportunity each year. Judges pictured from left to right are Sen. Paul Sarbanes, Maryland comptroller Louis Goldstein, and Alan Tyler. (Courtesy Crisfield Area Chamber of Commerce.)

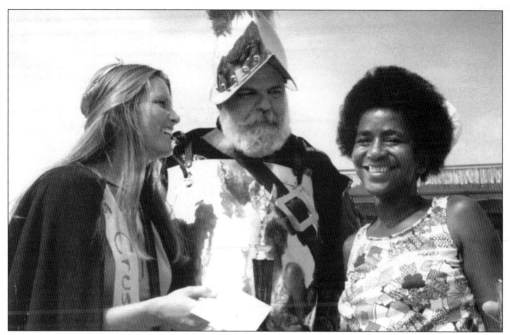

DE SOTO PAYS A VISIT. Hernando de Soto joined Miss Crustacean 1977 Lisa Riggin (left) in presenting that year's crab-picking winner, Carpathia Miles, with her trophy. De Soto visited the Crab Derby as part of an exchange program between Crisfield and Bradenton, Florida, home of the De Soto Heritage Festival. (Photograph by Scorchy Tawes, courtesy Crisfield Area Chamber of Commerce.)

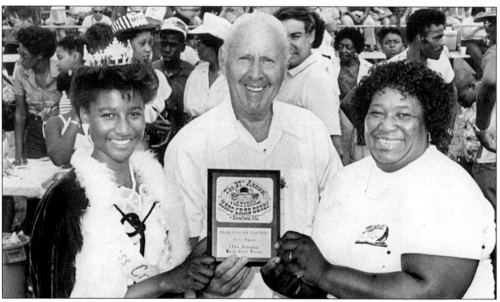

1984 WINNER. Miss Crustacean 1984 Joy Whittington (left) and Maryland comptroller Louis L. Goldstein congratulated 1984 crab-picking winner Grace Ward, who picked 3.66 pounds. The logo on the plaque was used for many years until the Crisfield Area Chamber of Commerce designed a new logo for the derby's 50th anniversary in 1997. (Photograph by Scorchy Tawes, Special to the *Crisfield Times*.)

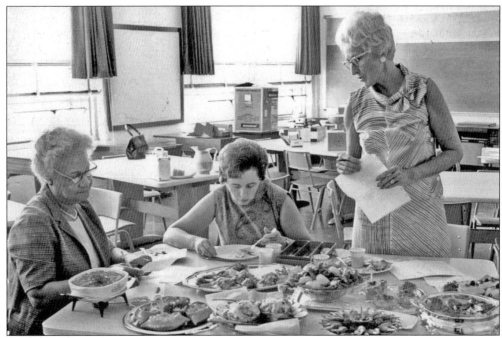

CRAB-COOKING JUDGES. Since 1965, the annual crab-cooking contest has been a Crab Derby mainstay, drawing some of the top amateur chefs from the mid-Atlantic. Judges at the contest in 1969 sampled each entry not only for flavor but for presentation as well. (Photograph by Scorchy Tawes, courtesy Crisfield Area Chamber of Commerce.)

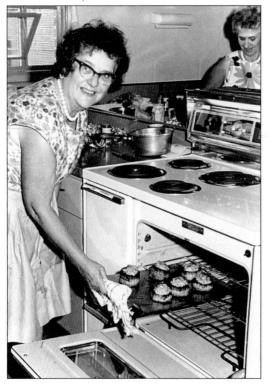

INAUGURAL WINNER. Mrs. James Blizzard won the first crab-cooking contest, set in the Crisfield High School home economics room in 1965. In the four decades that have followed, the contest has drawn national accolades. In the 21st century, it has been featured on the Food Network television show *Taste of America* and helped the derby earn a spot among the 10 great festivals in the nation to sample seafood as ranked by *USA Today*. (Photograph by Scorchy Tawes, courtesy Crisfield Area Chamber of Commerce.)

MAN IN THE KITCHEN. Male contestants were unusual during the cooking contest's earliest years. One of the first was Robert Cox, seen here at the 1970 competition. Today an equal mix of men and women can be found in the kitchen competing in the annual event. (Photograph by Scorchy Tawes, courtesy Crisfield Area Chamber of Commerce.)

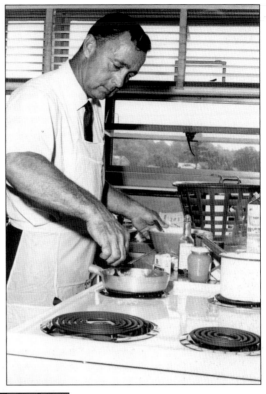

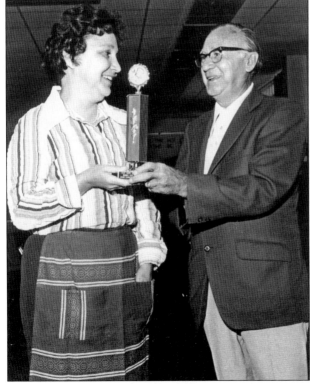

1978 WINNER. Mrs. Luke C. Smith took top honors at the 30th National Hard Crab Derby crab cooking contest. Each year's winner has his or her recipe added to the official Crab Derby cookbook, sold by the Crisfield Area Chamber of Commerce to raise money for the annual event. (Photograph by Scorchy Tawes, courtesy Crisfield Area Chamber of Commerce.)

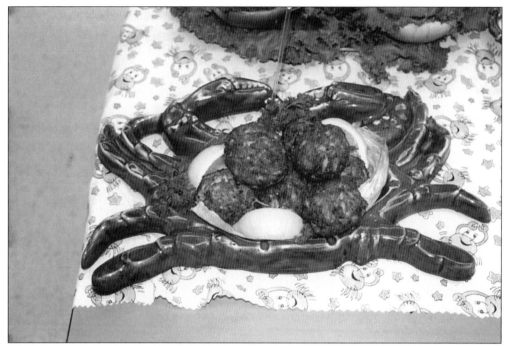

FINISHED ENTRY. This is what it's all about. Competitors at the annual cooking contest compete in four categories: appetizer, soup, crab cake, and main dish. The only rule: the main ingredient must be Maryland blue crab meat. After all, Crisfield is known as the Seafood Capital of the World.

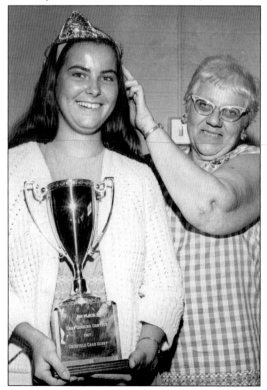

1967 CHAMPION. Miss Crustacean was not the only winner to receive a tiara at the 19th National Hard Crab Derby. Ruth B. Russell of Bridgeville, Delaware, winner of the 1966 crab cooking contest, crowned 1967 winner Nikki Dixon queen of the cooks. Dixon won with her recipe Deviled Crab Delight. (Photograph by Scorchy Tawes, courtesy Crisfield Area Chamber of Commerce.)

Five

BOAT RACES

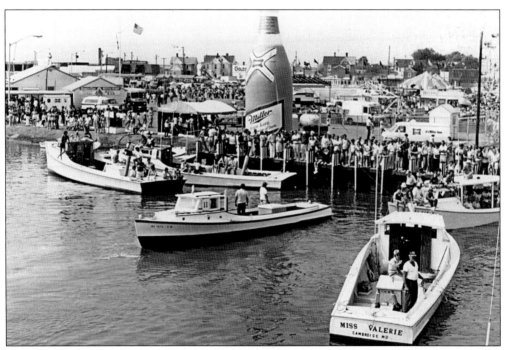

BOATING CONTESTS. Boat races of many sorts have been a part of the National Hard Crab Derby since the 1950s. One of the most popular, the annual boat docking contest, drew crowds by land and sea to Somers Cove Marina in 1979. (Photograph by Scorchy Tawes, courtesy Crisfield Area Chamber of Commerce.)

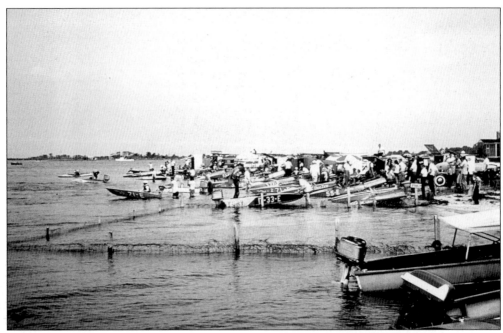

POWERBOAT RACES. The earliest water-bound vessels to race at the Crab Derby were powerboats, a popular addition to the annual slate of events in the early 1950s. Seen at Brick Kiln Beach in 1958, these speedboats are lined up beside the beach's swimming area, which was cordoned off to help keep out sea nettles.

SPEEDBOATS. A close-up view of the crafts offers a better look at their size and shape. Their small, sleek design made them faster and more powerful than most boats used in the Crisfield area at that time.

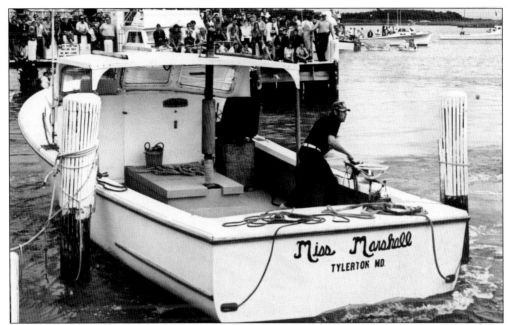

MISS MARSHALL. For many years, Dwight Marshall was the undisputed king of the boat-docking contest. From the event's inception in 1971 to his final victory in 1987, he won a dozen times, more than any other contestant before or since. Here his boat, the *Miss Marshall*, is seen during the 1979 contest. The *Miss Marshall* won that year's inaugural team competition. (Photograph by Scorchy Tawes, courtesy Crisfield Area Chamber of Commerce.)

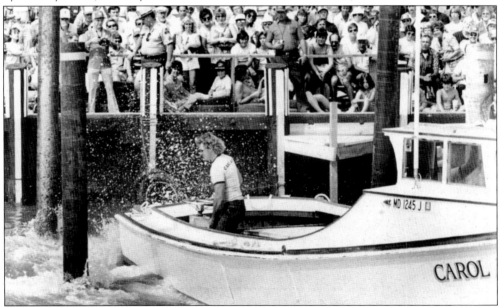

CAROL ANN. The *Carol Ann* kicked up the waters of Somers Cove Marina during the 1984 boat-docking contest. The spectators in the background offer proof of how popular the event has been over the years. In the early 21st century, derby officials decided to capitalize on its ability to draw a crowd, for the first time charging spectators an admission to view the contest. (Photograph by Scorchy Tawes, courtesy Crisfield Area Chamber of Commerce.)

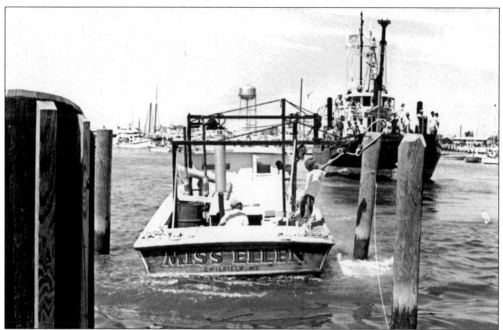

MISS ELLEN. The *Miss Ellen* had pulled into the docking area during this 1986 shot, but the clock continued to tick until ropes secured the boat to all four pylons. Contestants are judged by how fast they can dock the boat between the pylons. (Photograph by Scorchy Tawes, courtesy Crisfield Area Chamber of Commerce.)

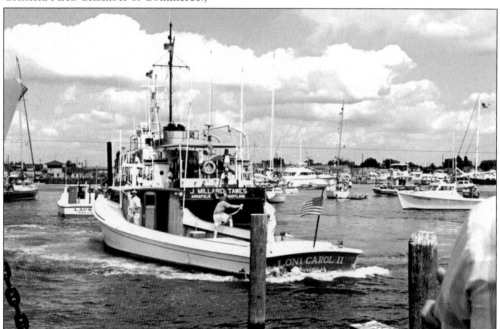

LONI CAROL II. The state boat *J. Millard Tawes* provided viewing for the contest in 1989 as the *Loni Carol II* of Tangier Island, Virginia, made its way between the pylons. All boats in the docking contest must be work boats, symbolizing Crisfield's generations-old tradition of making a living on the water.

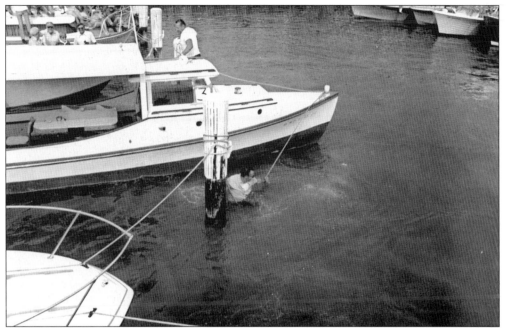

MAN OVERBOARD! One of the most fun parts of the boat-docking contest (for the spectators, not the participants) is when a captain makes a misstep and ends up making a real splash. Such was the cases for this unfortunate competitor in 1977. Captains or crew falling overboard are automatically disqualified. (Photograph by Scorchy Tawes, courtesy Crisfield Area Chamber of Commerce.)

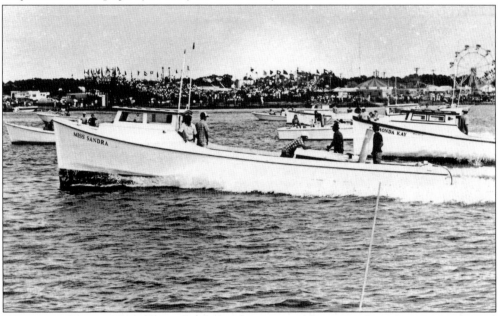

WORKBOAT RACES. Throughout the derby's history, workboat races have been an occasional event. The races recalled a time during the early- and mid-20th century when those who worked the water attempted to beat one another from Tangier Sound and the Chesapeake Bay back to Crisfield, where the first catches delivered to local packing houses often earned the most money. The Crab Derby grounds at Brick Kiln can be seen in the background of this 1980s race.

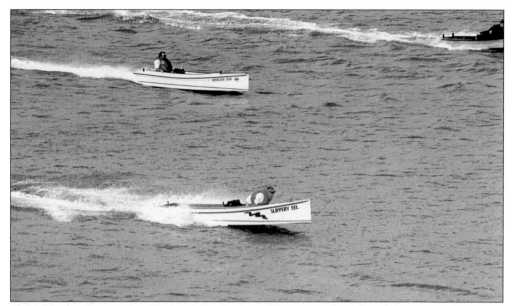

SKIFF RACES. During the 50th Crab Derby in 1997, the J. Millard Tawes Museum and Visitors Center received a boat-building challenge from the Oxford Racing Syndicate, which had built a racing skiff following a 1922 design by Smith Island resident Lawson Tyler. A committee standing in for the museum answered the challenge by building its own 1922 replica, the *Renegade Crab*, ready to race at the 51st derby. The *Crab* won the inaugural event in 1998 against Oxford's *Slippery Eel*, both seen here in 1999.

PLASTIC BOTTLE BOAT REGATTA. A part of the National Hard Crab Derby since about 1979, the plastic bottle boat regatta began as a way to preserve Crisfield's boatbuilding heritage in a way that allowed everyone to participate. Comprised chiefly of wood, chicken wire and dozens of empty milk jugs, the boats sometimes were more seaworthy than their captains! (Photograph by Scorchy Tawes, courtesy Crisfield Area Chamber of Commerce.)

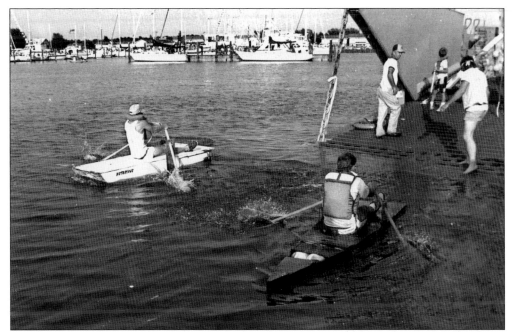

CASTING OFF. Initially held at Brick Kiln Beach, the regatta had moved to the U.S. Coast Guard Station adjacent to Somers Cove Marina by the time this photograph was taken. Though children often comprised the majority of the event's competitors, the event offered a category for adults as well. (Photograph by Scorchy Tawes, courtesy Crisfield Area Chamber of Commerce.)

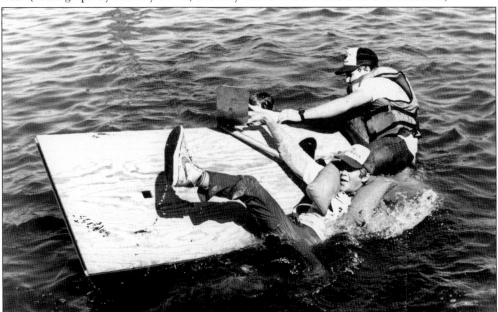

TAKING A DIVE. The captains of this craft struggled to hang on until the finish line. During the event's early years, the *Crisfield Times* annually provided plans for youngsters wishing to build boats for the contest, including this raft model. Captains had the option of paddling their homemade vessels or hanging their feet off the back and providing their own motor via leg power. (Photograph by Scorchy Tawes, courtesy Crisfield Area Chamber of Commerce.)

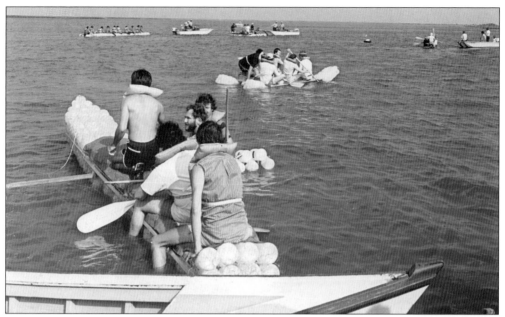

WATCHING THE REGATTA. As with many of the derby's boating competitions, vessels anchored off shore from Brick Kiln Beach afforded a good view of the 1979 plastic bottle boat regatta. Early contest rules offered a little-known fact: one empty, sealed one-gallon plastic milk jug will support an average of eight pounds on the water. (Photograph by Scorchy Tawes, courtesy Crisfield Area Chamber of Commerce.)

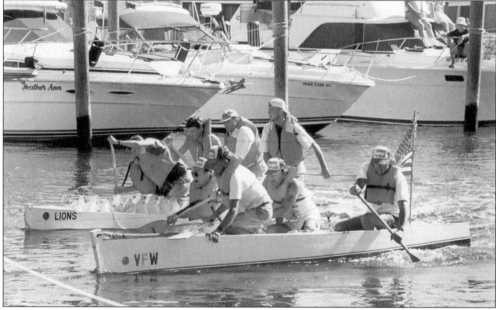

NEW LEVEL. Combating waning interest that plagued the contest in the 1990s, the Crisfield Lions Club and Veterans of Foreign Wars Somerset Memorial Post 8274 took the plastic bottle boat regatta to a whole new level in 1997, eliminating the annual boat creation process in favor of pre-fabricated boats made to last for years at a time. Seen here, the two teams prepared to make the turn to the finish line.

Six

BOAT PARADE

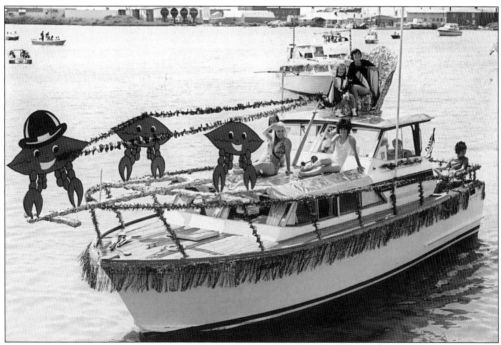

A-GO-GO. Capt. Carlton Drewer led the boat parade in style during the Crab Derby's 25th anniversary in 1972 featuring Miss Crustacean Ann Parks, Little Miss Crustacean Vonda Mason, and their court aboard his boat, the A-Go-Go. The plywood crabs pulling the garland reins were used as decorations at many derby events for years before retiring to Drewer's shed. They briefly returned to Somers Cove Marina in 1997 for the derby's 50th anniversary. (Photograph by Scorchy Tawes, courtesy Crisfield Area Chamber of Commerce.)

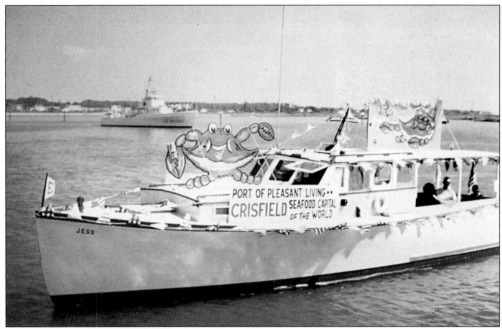

PORT OF PLEASANT LIVING. The *Jess* referenced National Bohemian Beer's famous slogan with this 1970s entry. The Maryland-based brewer touted its home state as the Land of Pleasant Living in 1960s and 1970s advertisements. The *Jess's* sign localized the title, claiming Crisfield as the Port of Pleasant Living.

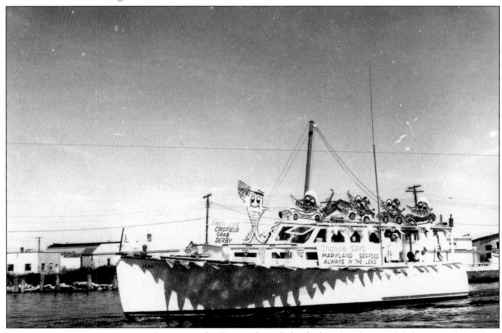

ALWAYS IN THE LEAD. Another year, the *Jess* enlisted the help of a plywood fish named for (but not resembling) Charlie Tuna of Star-Kist fame to spread the message "Maryland Seafood: Always in the Lead." Charlie waved the checkered flag as a foursome of Chesapeake Bay blue crabs made their way toward the finish line in an auto race.

CHESTER PEAKE. For many years, National Bohemian sent its own entry to the boat parade in the form of the *Chester Peake*, a converted skipjack named for the brewer's spokes-seagull, featured on the sail. Seen here in 1966, the *Chester Peake* and its captain, Com. Frank Hennessy, not only served as a goodwill ambassador for the company, but temporarily helped preserve one of a dwindling skipjack fleet that has shrunk to fewer than a dozen in the 21st century.

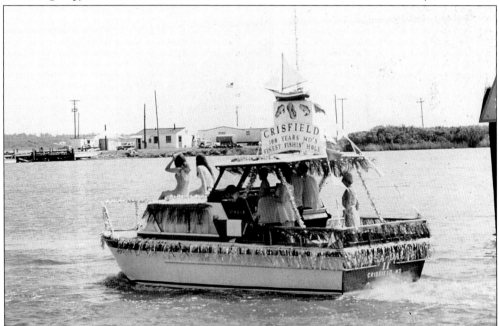

MARYLAND'S FINEST FISHIN' HOLE. Celebrating the centennial anniversary of Crisfield's founding in 1866, this 1966 boat parade entry proclaimed the city as "100 Years Maryland's Finest Fishin' Hole." The painted fish beneath the model skipjack on top of the vessel seems to attest to that idea.

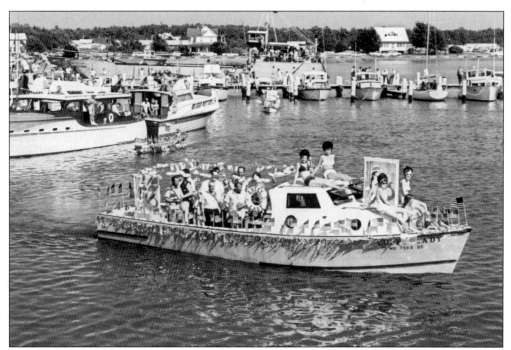

LUCKY LADY. Bathing beauties and friends gathered aboard the patriotically decorated *Lucky Lady* for the 1969 boat parade. Spectators lined up aboard the undecorated boats along the parade route. (Photograph by Scorchy Tawes, courtesy Crisfield Area Chamber of Commerce.)

BROWN'S OUTBOARD SERVICE. The highlight of the boat parade for many years, this entry from Brown's Outboard Service of Pocomoke City, Maryland, resembled a miniaturized tugboat. The boat was created to help the business promote sales of Johnson outboard motors.

KING CRAB. The crown atop the crab on this 1973 boat parade entry summed up the driving force behind Crisfield's economy throughout much of the 20th century. Known as the Seafood Capital of the World, Crisfield's major export shifted from oysters to crabs as oyster supplies dwindled, leading to the city's annual crustacean celebration in the form of the Crab Derby.

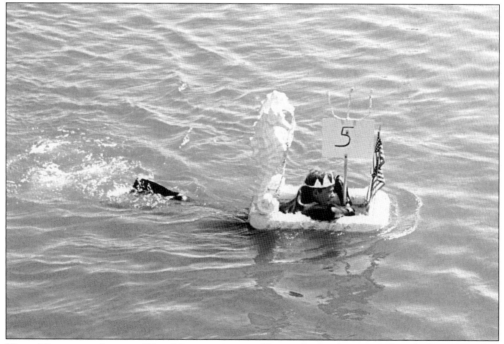

KING NEPTUNE. A young King Neptune powered his seahorse-driven craft with flippers in this boat parade entry. One of the parade's most unique participants, the vessel combined nautical legend with patriotism, featuring both the king's triton and an American flag.

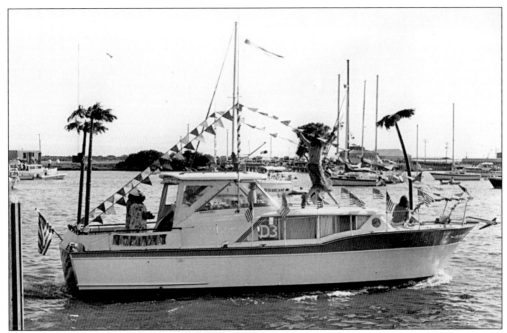

MERMAIDS. Tropical islands and mermaids topped this boat parade entry, invoking another legend of the sea. While no mermaids ever have been spotted off the coast of Crisfield and the nearest palm trees are hundreds of miles away, the nautical theme aboard this boat rang loud and clear. (Photograph by Scorchy Tawes, courtesy Crisfield Area Chamber of Commerce.)

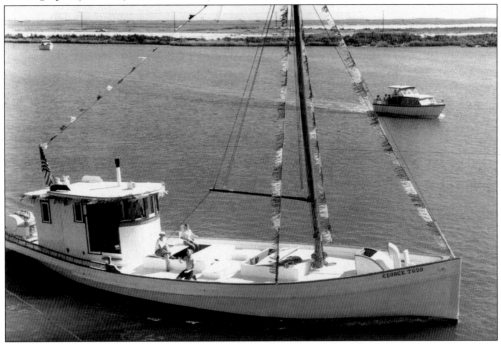

GEORGE TODD. Recreational craft were not the only entries in the boat parade. In the 1960s, workboats like the *George Todd*, pictured here, doffed their cargos in favor of more colorful décor to celebrate the Crab Derby. (Photograph by John McIntosh, courtesy Mary Nelson.)

Seven

MAIN STREET PARADE

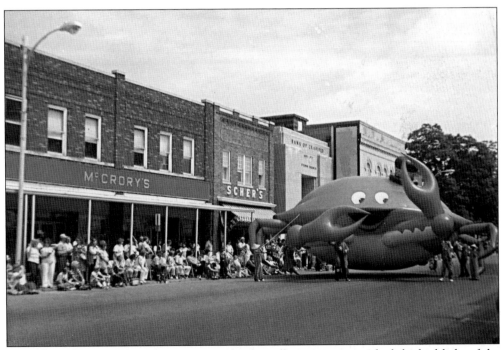

CRAB BALLOON. A once-only appearance by this jolly crustacean marked the highlight of the 1981 Crab Derby Main Street Parade. Handlers had to keep the balloon low to the ground to avoid power lines and low branches along the route. Main Street has undergone a vast transformation since this photograph was taken. None of the three businesses seen in the background—McCrory's, Scher's, and the Bank of Crisfield—exist in the city today.

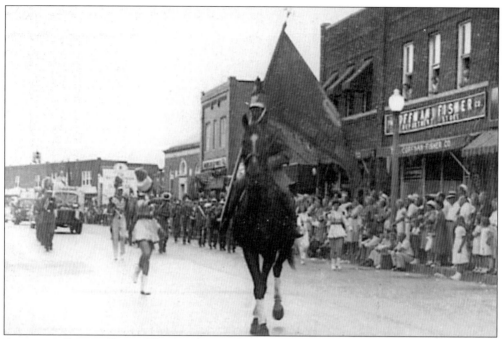

AMERICAN LEGION BAND. The Stanley Cochrane Post 16 American Legion Band led by King Sterling appeared in the early Crab Derby parades, the first of which was in 1950. Unlike today's parades that travel west on Main Street, the inaugural Crab Derby parades faced east, as seen in this early photograph.

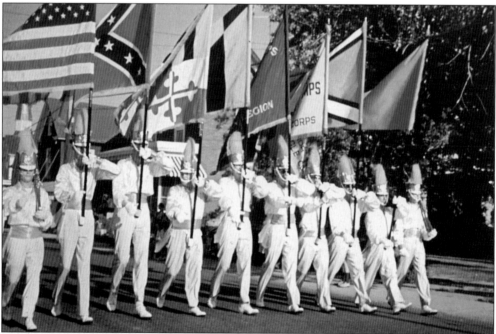

AMERICAN LEGION FLAG CORPS. Marchers carried flags representing a variety of places and eras in this 1960s image. The tall plumed hats the corpsmen wore were used by many similar marching units and bands of the era.

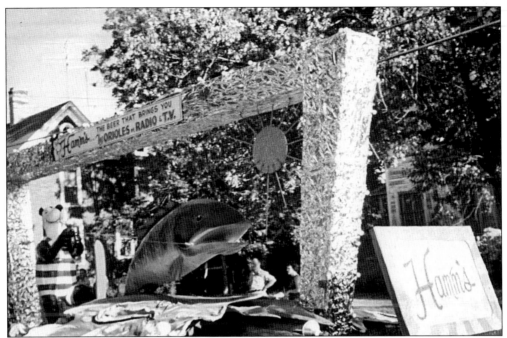

HAMM'S BEER. Featuring the Hamm's Bear, this 1960s float paid tribute to the Maryland state fish, the striped bass, while reminding parade viewers that Hamm's was the beer that brought them coverage of Baltimore Orioles baseball on radio and television. In Crisfield, crab racing was second only to baseball in the hierarchy of popular sports.

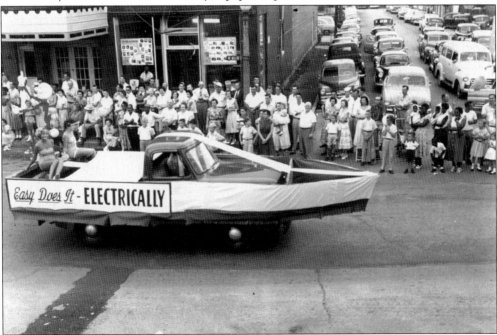

EASY DOES IT. A local electrician sponsored this 1960s float. Complete with two bathing beauties on the back, the boat-shaped entry gave a new meaning to the word "float." (Photograph by John McIntosh, courtesy Mary Nelson.)

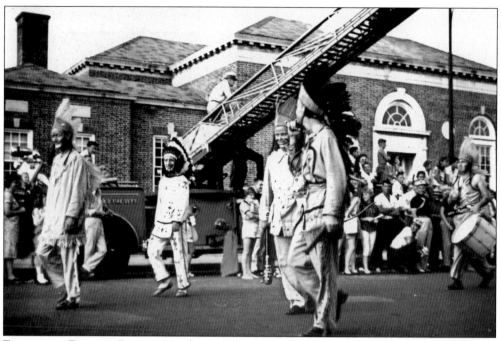

FRUITLAND REDMEN LODGE. Members of the Improved Order of Redmen Lodge of Fruitland passed the Crisfield Post Office in this 1966 view. The Crisfield fire truck in the back helped suspend one of the derby's famous yellow banners overhead. Featuring a red crab in the middle, the durable cloth banners read, "Welcome—National Hard Crab Derby—Labor Day Weekend."

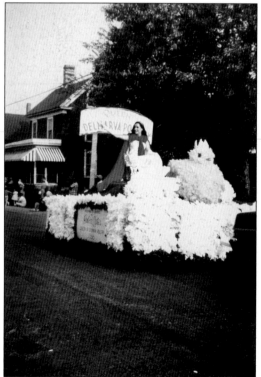

DELMARVA POULTRY QUEEN. The 1966 Delmarva Poultry Queen, Robin Dukes, traversed the parade route atop her throne accompanied by a giant chick. The queen was chosen each year as part of the Delmarva Chicken Festival, a salute to one of the area's largest industries. The annual celebration continues into the 21st century, rotating from town to town on the Delmarva Peninsula.

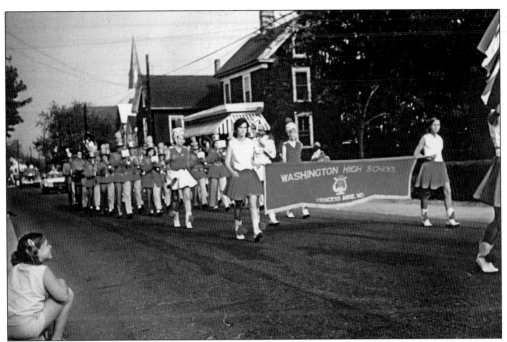

WASHINGTON HIGH SCHOOL BAND. A part of the Main Street Parade for decades, the Washington High School Band is seen here in 1966. At one time, the parade drew at least a dozen high school bands annually from throughout the Delmarva Peninsula. With budget cuts and changes in local school policies, Crisfield and Washington have been the only two school bands associated with the parade since the early 1990s.

SOMERSET COUNTY TERCENTENARY. Lady Somerset, beneath the arch, accompanied Lady Wicomico (left foreground) and Lady Worcester (right) atop the Somerset County Tercentenary float in 1966. The float celebrated the county's 300th anniversary. At its founding in 1666, Somerset County comprised much of what eventually became Worcester and Wicomico Counties. Today the three neighboring counties make up Maryland's lower Eastern Shore.

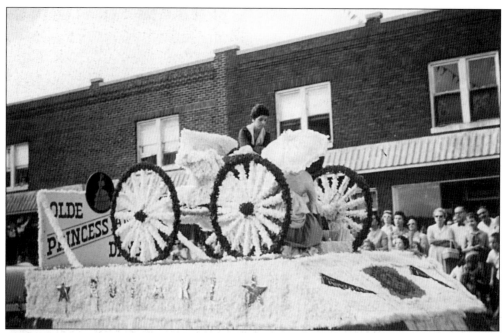

OLDE PRINCESS ANNE DAYS. The Princess Anne Historical Society celebrated its annual festival, Olde Princess Anne Days, with this 1966 float, sponsored by the Princess Anne Rotary Club. Held every October, Olde Princess Anne Days highlights some of the oldest homes in Somerset County, including historic Teackle Mansion.

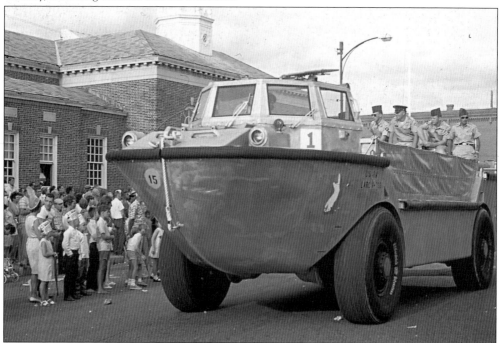

AMPHIBIOUS DUCK. The U.S. Army showcased one of its most unique vehicles, the amphibious duck, in this 1960s parade. Created to traverse both land and water, the duck took derby patrons on brief tours of Crisfield Harbor following its ride down Main Street.

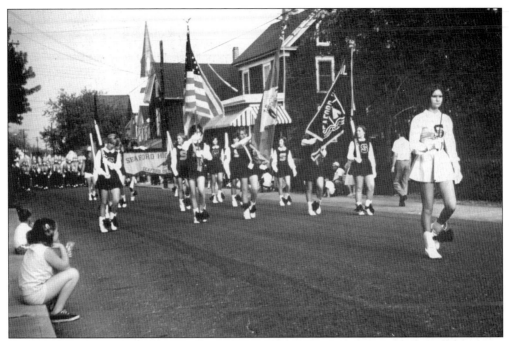

SEAFORD HIGH SCHOOL BAND. The Seaford High School Marching Band of Delaware was among those participating in the parade in the 1960s. Parade participants, especially those from out of state, always were invited to remain afterward and enjoy the rest of the derby festivities.

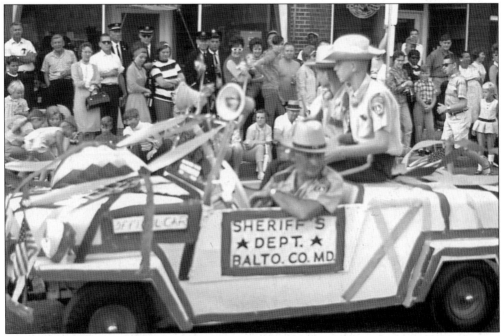

BALTIMORE COUNTY SHERIFF'S DEPARTMENT. The streamers weren't exactly standard issue, but the Baltimore County Sheriff's Department made itself known in Crisfield during this 1968 parade. Among those in the background are members of the Crisfield Volunteer Fire Department who had already ended their march along the parade route.

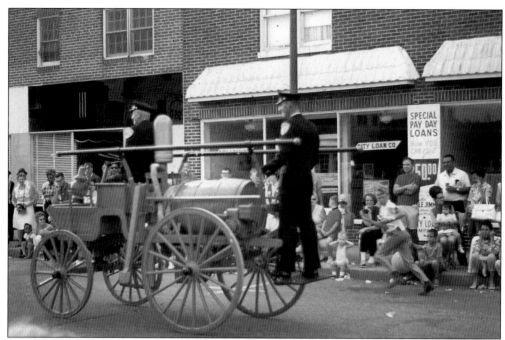

CHINCOTEAGUE VOLUNTEER FIRE COMPANY. This antique fire apparatus represented the Chincoteague Volunteer Fire Company of Virginia during the 1968 parade. The youngster with his hands over his ears to the right of the fireman on the back likely illustrates that a marching band was not too far behind.

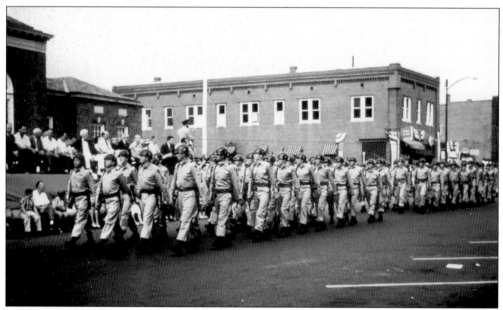

1229TH TRANSPORTATION COMPANY. Crisfield's Maryland Army National Guard 1229th Transportation Company had existed for only two years when the unit marched in the 1970 parade, pictured here. The company was formed following the reorganization of Crisfield's Company L National Guard unit in 1968. The 1229th continued its participation in the parade nearly every year until the early 21st century. The company was transferred to Baltimore in 2005.

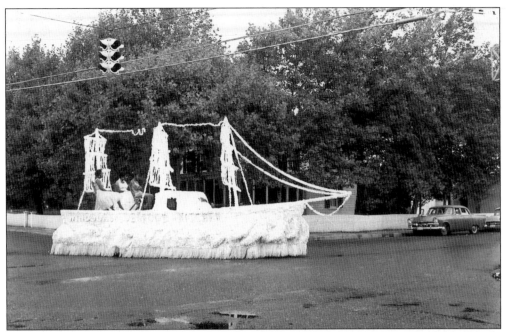

WINDSOR'S SEAFOOD KITCHEN. Crisfield's venerable seafood restaurant on West Main Street hosted this ship-shape float in 1970. Seen at the intersection of Main Street and Somerset Avenue, the float was either on its way to or coming back from the parade when this photograph was taken.

SPARKY BYRD. Crisfield has its share of characters, and Sparky Byrd was one of them during the 1969 parade, when he dressed as a baby for the festivities. Instead of walking the parade route the next year, he opted to ride in the back of a pickup truck in full drag with a sign on the side reading "Crisfield Peeler." (Photograph by Scorchy Tawes, courtesy Crisfield Area Chamber of Commerce.)

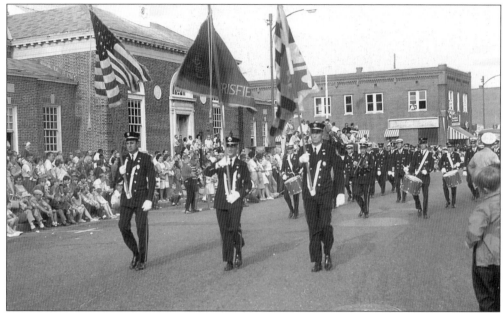

CRISFIELD VOLUNTEER FIRE DEPARTMENT. A part of the Main Street Parade since the event's beginning, the Crisfield Volunteer Fire Department has served in a number of capacities. In the early 1950s, it provided transportation for willing Miss Crustacean contestants in the parade aboard fire trucks. Seen here in the early 1970s, the department furnished a drum corps and color guard for the occasion.

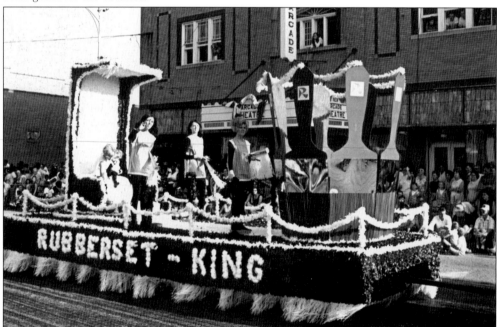

RUBBERSET FLOAT. At the time one of Crisfield's largest employers, Rubberset Company sponsored this entry in the 1970 Main Street Parade. The giant paintbrushes on the front symbolized the company's chief export in grand form. (Photograph by Scorchy Tawes, courtesy Crisfield Area Chamber of Commerce.)

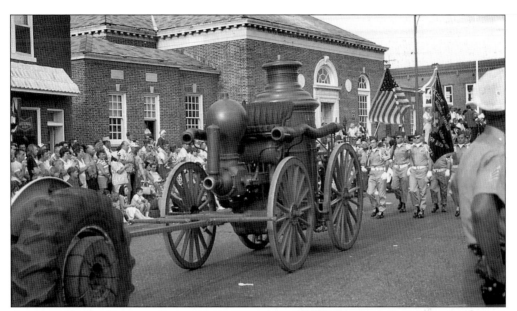

ANTIQUE STEAM PUMPER. For many years, the Main Street Parade just would not have been complete without an appearance by the Crisfield Volunteer Fire Department's 1885 Clapp and Jones steam pumper. Purchased new for $2,800, the vehicle received the finest care the department could offer. In early parades, it was horse-drawn. In this 1970s view, a tractor filled in for the equine. No longer a part of the parade, the pumper is on permanent display at the Chesapeake Fire Museum in Hebron, Maryland.

MARIE FRANK DANCERS. A highlight of both the 1973 parade and Crab Bowl performances were the Marie Frank Dancers, waving to the crowd from atop their rainbow float. The Baltimore County–based dance troupe performed upon the Showmobile stage following the parade.

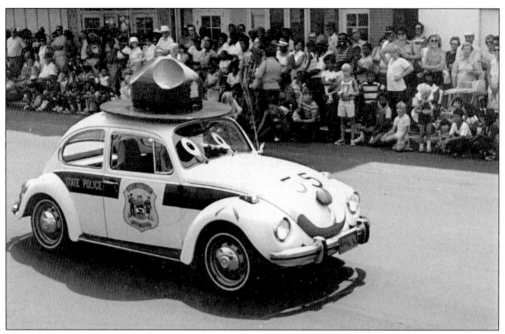

TROOPER DAN. The goodwill ambassador for the Delaware State Police, this vintage Volkswagon Beetle toured the Delmarva Peninsula. Seen here in 1979 during one of many Crab Derby appearances, the original Trooper Dan was retired and replaced with a newer model Beetle in 2000.

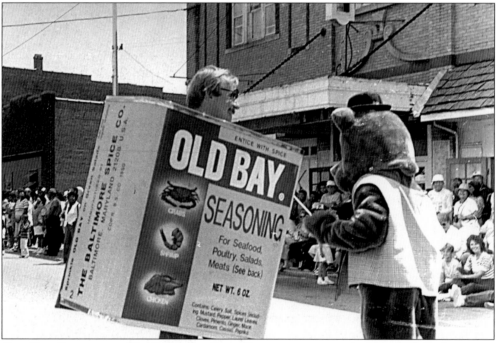

OLD BAY SEASONING. The Baltimore Spice Company sponsored many Crab Derby events throughout the years. In 1986, the company sent its Old Bay corporate spokes-can to entertain parade viewers. Here the costumed can chats with a friend along the parade route in front of the former New Arcade Theater.

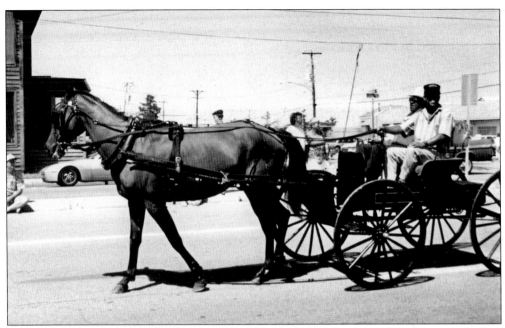

GRAFTON WILLIAMS. Another longtime Crab Derby staple, Ponderosa Farms owner Grafton Williams rode this wagon during a 1980s Main Street Parade. Williams rode either his horse or the wagon along the parade route through the late 1990s, when health issues forced him to put down his reins. Derby officials saluted him as the parade's grand marshal in 2000.

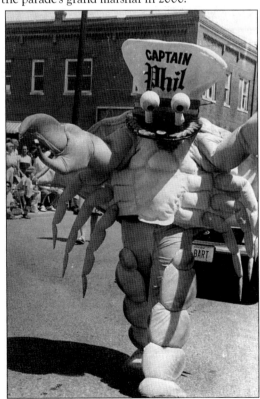

CAPTAIN PHIL. Promoting Phillips Seafood Restaurant in Ocean City, Maryland, Captain Phil welcomed parade viewers to the Crab Derby in 1986. Costumed characters have long been a part of the Main Street Parade despite the blazing heat their wearers must endure along the parade route.

CRISFIELD HIGH SCHOOL BAND. Founded in 1973, the modern Crisfield High School Marching Band is seen with its original banner in this 1980s shot. During its first year, the band marched in the Main Street Parade without a banner or uniforms; instead they wore regular street clothes as they performed.

ORIGINAL UNIFORMS. Seen here in the 1970s, the band's original uniforms were navy blue and gold. The heavy material was more suitable for winter marching than summer performances. However, the band was not going to deprive its hometown of seeing them in full dress uniforms during the city's biggest annual celebration.

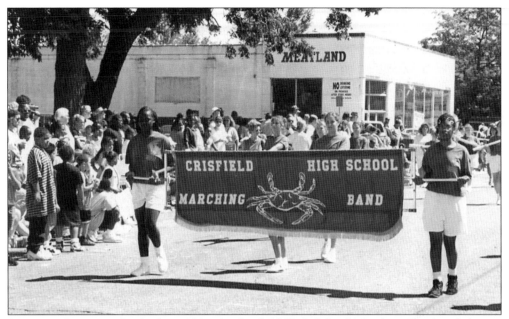

SUMMER UNIFORMS. In the late 1980s, the Crisfield High School Marching Band traded in its original banner for a newer version more representative of the school and community. The new banner featured a crab in the middle, surrounded by material and fringe in the school's colors, purple and gold. Seen here in 1997, the band had switched to summer uniforms for its annual Crab Derby performances, wearing purple T-shirts and white shorts.

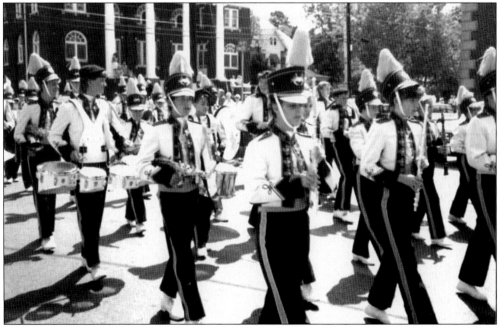

CRUSTACEAN CAPS. The Crisfield High School Marching Band wore the second version of their uniforms at the Crab Derby only for a handful of years before switching to summer uniforms in 1992. Seen here in 1989, the new uniforms featured a crab on each plumed hat, another reminder of the city's seafood heritage.

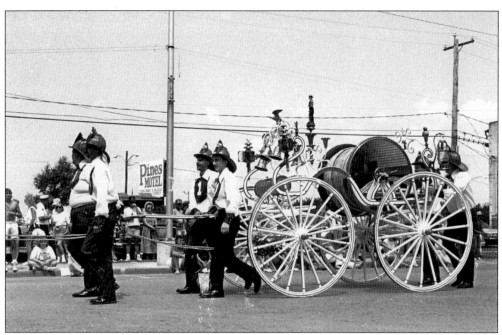

INDEPENDENT HOSE COMPANY NO. 1. A fixture of the Main Street Parade since 1958, Frederick, Maryland's Independent Hose Company No. 1 is almost as much a part of the Crab Derby as the crustaceans themselves. The company's hand-pulled antique fire apparatus is the oldest piece of equipment ever to appear in the parade.

POCOMOKE VOLUNTEER FIRE DEPARTMENT. The Pocomoke Volunteer Fire Department adds another antique fire apparatus to the annual parade with its 1923 engine. Seen here during the 50th Crab Derby in 1997, the vehicle is a highlight of parades throughout the Delmarva Peninsula and serves as a token of goodwill for the department.

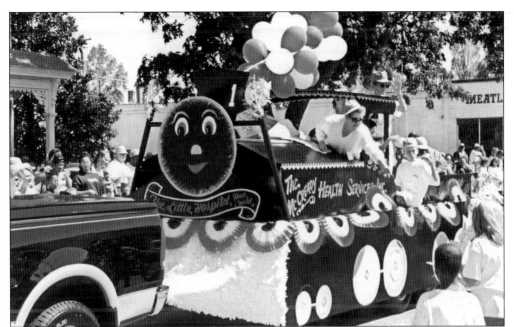

MCCREADY HEALTH SERVICES FLOAT. The McCready Health Services Foundation celebrated its prosperity in the 1990s with this float, the Little Hospital That Could. A part of the parade in 1997, the float marked the foundation's growth from a single hospital in 1923 to the addition of the Alice Byrd Tawes Nursing Home and a chain of outpatient centers three-quarters of a century later.

CHESTER RIVER SHRINE CLUB. This chapter of the Boumi Temple was "Clowning to help burned and crippled children" during the 2001 Main Street Parade, according to the sign on this boat. Featuring several boats named for each of Maryland's upper Eastern Shore counties, the group performed stunts along the parade route while raising awareness of its cause.

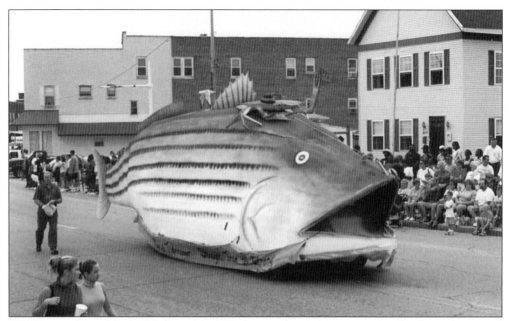

ECI Float. One of the highlights of Crab Derby parades in the 21st century has been the annual floats entered by the Eastern Correctional Institution, made over several months by inmates at the state prison in nearby Westover, Maryland. The 2001 installment, entered during the 54th Crab Derby, was this oversized rockfish. Thanks to a pulley system installed inside, the fish moved its tail as it traversed the parade route.

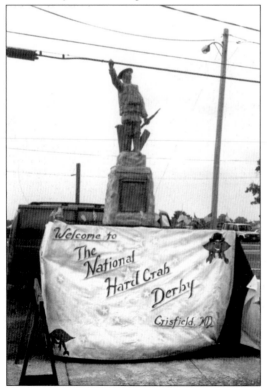

Spirit of the American Doughboy. Since 1922, an original Ernest Moore Viquesney "Spirit of the American Doughboy" statue has served as the centerpiece of Crisfield Veterans Cemetery. Reproduced in papier-mache by inmates at the Eastern Correctional Institution, the statue also adorned the judges' stand of the 2001 Main Street Parade. The skirting, also designed by ECI inmates, features another tribute to Crisfield's heritage. The crabs in the corners are paintings of those that once pulled the *A-Go-Go* through the Crab Derby boat parade.

Eight

EVENTS AND ENTERTAINMENT

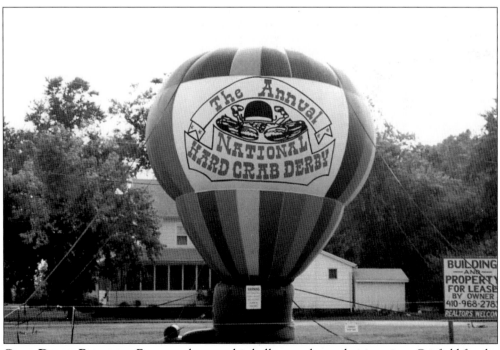

CRAB DERBY BALLOON. For several years, this balloon welcomed visitors into Crisfield for the National Hard Crab Derby. The balloon featured the traditional Crab Derby logo, used until the 50th-anniversary design was introduced in 1997.

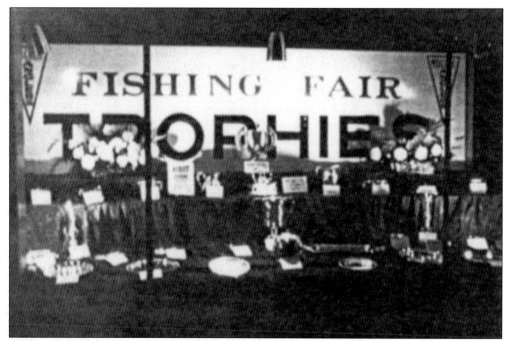

FISHING FAIR TROPHIES. Trophies for the 1950 Chesapeake Bay Fishing Fair were displayed during that year's event, which kicked off August 19. The fair raised the Crab Derby to a whole new level of success, and Crisfield eventually became the annual state tournament's permanent home.

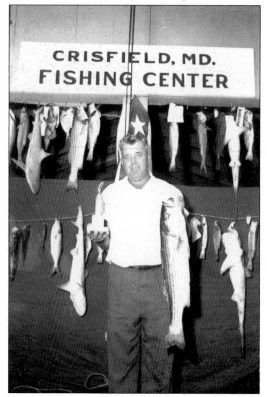

FISHING FAIR WINNER. Leon "Fleabait" Sterling displayed his winning catch and trophy during the 1959 Chesapeake Bay Fishing Fair, held in connection with the Crab Derby. A longtime local waterman, Sterling was one of many Crisfield residents who made it a point to compete in the tournament nearly every year.

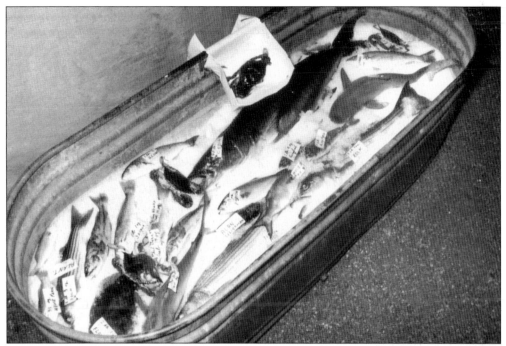

CATCH OF THE DAY. This rare photograph shows how fish were kept once caught at the fishing fair. The tub full of ice kept the fish fresh while the tags denoted their weight and who caught them, ensuring a quick tally for the winners once the tournament ended.

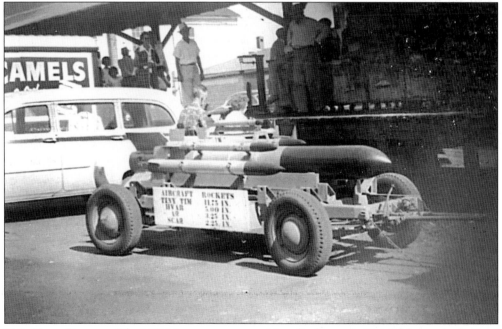

U.S. NAVY DISPLAY. The U.S. Navy set up a recruiting display at the Crisfield steamboat wharf during the sixth Crab Derby in 1953. The navy used the display to gain new recruits at the festival, as well as strengthen its image within the community. Aircraft rockets displayed aboard this cart include the Tiny Tim, High-Velocity Artillery Rocket, and Sub-Caliber Aircraft Rocket.

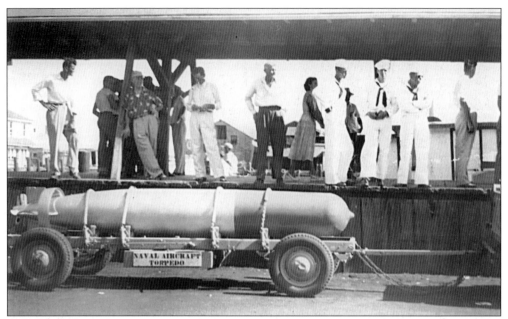

AIRCRAFT TORPEDO. U.S. Navy seamen were on hand to answer questions about this display, a naval aircraft torpedo. While it has not seen such a weapon for a while, the Crisfield City Dock remains virtually unchanged otherwise more than half a century after this photograph was taken.

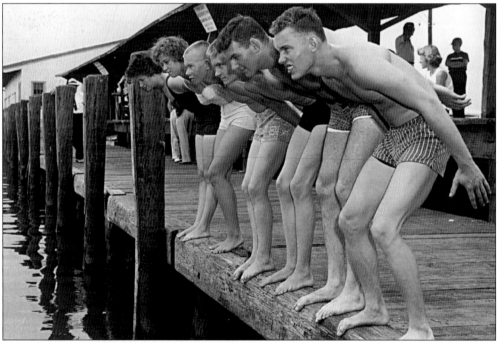

SWIMMING CONTEST. Early swimming contest participants prepared to dive off the Crisfield City Dock in this 1950s photograph. Unlike more modern Crab Derby swim meets, which are held at the Somers Cove Marina pool, the earliest swimming contests took place right in Crisfield Harbor. Races ranged from one-quarter to half of a mile.

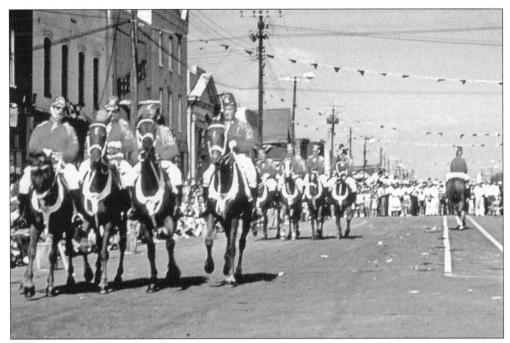

BOUMI TEMPLE EXHIBITION. The Boumi Temple put on an equine exhibition during the 11th National Hard Crab Derby in 1958. Seen here at the end of West Main Street, it is likely the temple members also rode in that day's Main Street Parade.

NAVY RECRUITING. The U.S. Navy again tried its hand at recruiting during this Crab Derby in the early 1960s. This time instead of featuring actual combat weapons, naval officials welcomed guests aboard a walk-on exhibit in the form of an antique sailing ship.

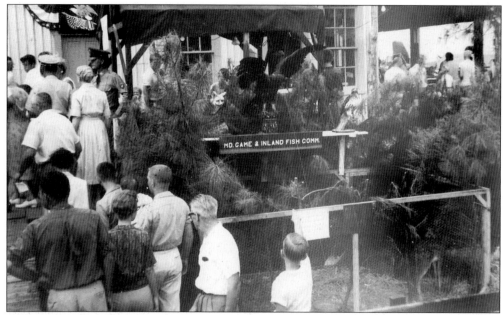

ARTS AND INDUSTRIAL FAIR. For more than a decade from 1950 through the early 1960s, the annual arts and industrial fair was a popular part of the Crab Derby. Originally held at the Crisfield Armory in conjunction with the third Crab Derby, the fair had moved to the city's steamboat wharf by the time this photograph was taken in the late 1950s. This outdoor exhibit featured trees and live and mounted wildlife. (Courtesy Maryland Game and Inland Fish Commission.)

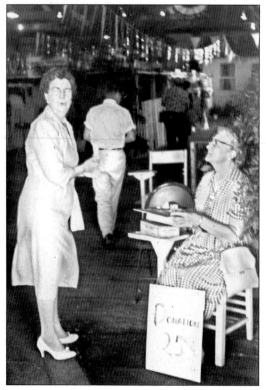

ENTERING THE FAIR. The outdoor exhibits were just a teaser for what awaited derby patrons inside the massive steamboat building at the end of the dock. Visitors paid an admission, in this case a donation of 25¢ per person, to see the weekend-long museum of marvels waiting beyond the front door.

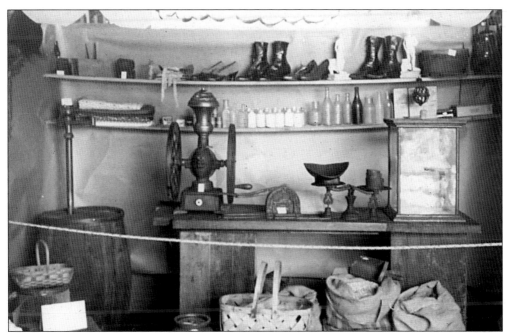

GENERAL STORE. From the antique coffee grinder and scales to the high-button boots on the top shelf, there was no mistaking this reproduction of an early-20th-century general store inside the arts and industrial fair. Bottles of baking powder and other supplies lined the shelves while other merchandise was kept in the baskets and barrels below.

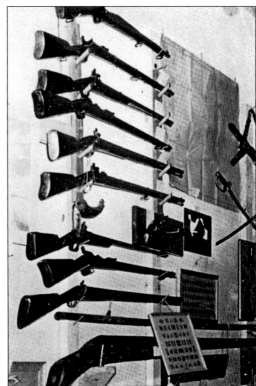

FIREARMS DISPLAY. One of the fair's most popular annual exhibits was the firearms display. Featuring everything from rifles to swords to ammunition, the exhibit held the attention of many men who reminisced about their own hunting collections and young boys who couldn't wait to own one of those hunting rifles themselves someday.

105

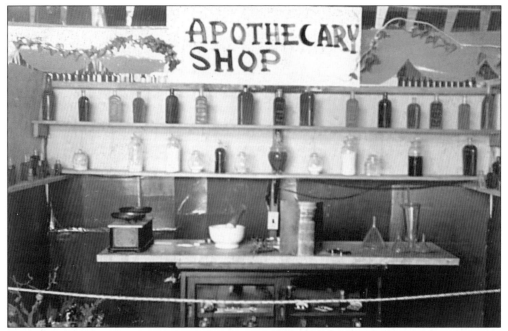

APOTHECARY SHOP. Vintage powders and potions lined the shelves of this 1960 exhibit, representing an old-time drug store. The mortar and pestle on the counter added to the display's realism. Many of the derby's older patrons likely remembered shops like this throughout the Crisfield area or in their own hometowns in the early 20th century.

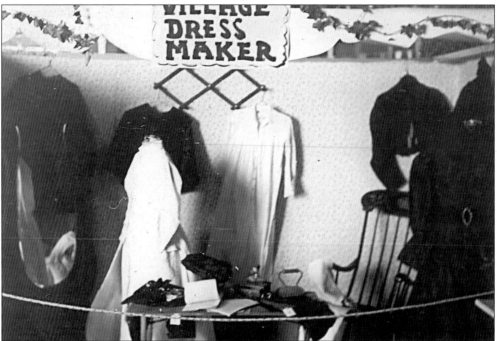

VILLAGE DRESS MAKER. Another re-creation of an early 20th century shop, this display offered a look at some ladies' styles of the past. The exhibit even included a hint to the maintenance these clothes needed, featuring an old-time flat iron on the table in front of the rocking chair.

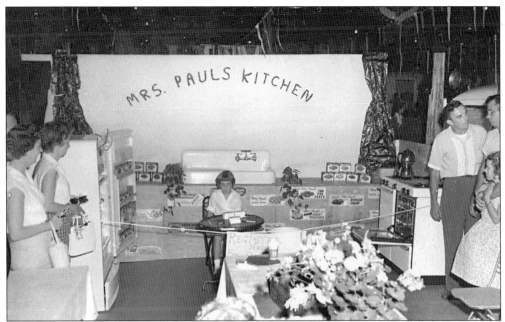

MRS. PAUL'S KITCHENS. Established in Crisfield in 1951, just five years after the seafood processing company's national founding in 1946, Mrs. Paul's Kitchens was one of the city's largest employers for decades. The company used the art and industrial fair as a way to display its latest products in this late 1950s photograph. Foods showcased here include codfish cakes, deviled crab, and frozen sweet potatoes.

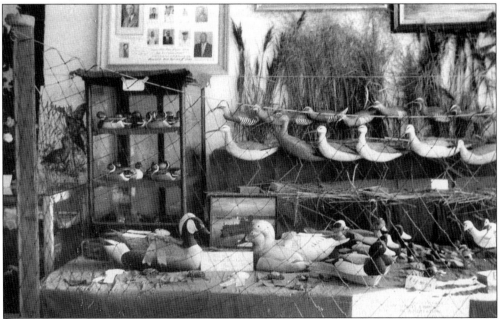

DECOYS. The home of world-famous carvers Lem and Steve Ward, Crisfield was legendary for its decoys even in the 1950s. This arts and industrial fair exhibit showcases some of those decoys with a few cattails and marsh plants thrown in for ambiance. If sold today, many of the carvings showcased here likely would bring in hundreds if not thousands of dollars.

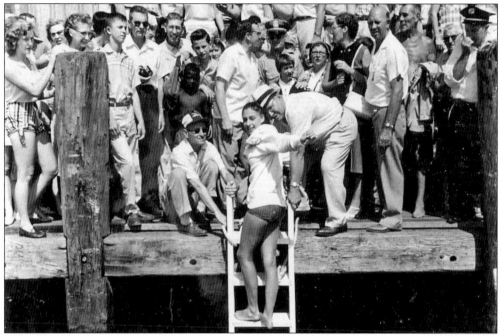

LONG-DISTANCE SWIMMER. The sweetheart of the 12th Crab Derby in 1959 was 15-year-old Terry Seehausen of Baltimore, shown here emerging from the water after a 5-hour, 12-minute swim from Smith Island to Crisfield. She later rode in that year's Main Street Parade carrying a sign proclaiming, "I swam Tangier Sound."

SHARPSHOOTER. Westerns were all the rage on television when this sharpshooter demonstrated his skill at the 12th Crab Derby in 1959. In the background is the board with the names of all of the year's crab race entrants. That year's winning crab: Miss North Ocean City.

AIR COMMAND BAND. The U.S. Air Force Tactical Air Command Band of Langley Field performed on West Main Street during the 1959 Crab Derby. Note the American flags and buntings in the background have only 48 stars. Hawaii became the 50th state just one week before that year's Crab Derby festivities.

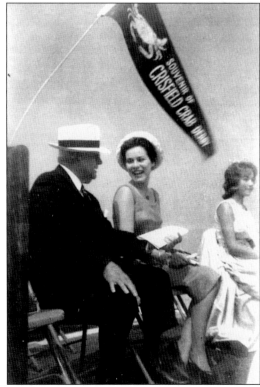

CRAB DERBY PENNANT. Crab Derby souvenirs have been few over the years, and one of the rarest was the blue and white pennant that waved over the heads of these derby guests in 1964. In the late 1970s, 1980s, and again for the 50th Crab Derby in 1997, derby officials offered a handful of souvenirs, including pins, mugs, key chains, and bumper stickers. However, few of these exist today. Pictured at far right is Miss Crustacean 1964 Annette Tawes.

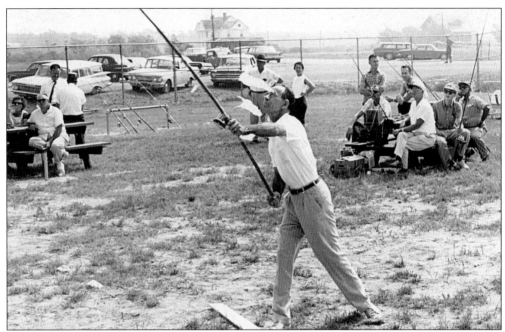

CASTING CONTEST. The 18th Crab Derby in 1965 included a rod and reel casting contest, seen here. Though the event did not take off as a Crab Derby contest, professional casters revisited Crisfield in the early 21st century, when the city became home to several regional, national, and international Sportcast USA competitions. (Photograph by John McIntosh, courtesy Crisfield Area Chamber of Commerce.)

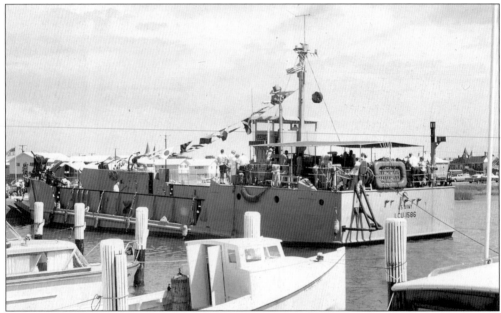

LANDING CRAFT. This U.S. Army landing craft unit visited the Crab Derby from Virginia in 1968. In a recruiting and public relations effort, military officials allowed civilians attending the derby to board and tour the craft, docked at Somers Cove Marina. The ship dwarfed the smaller yachts and pleasure boats more commonly seen at the marina.

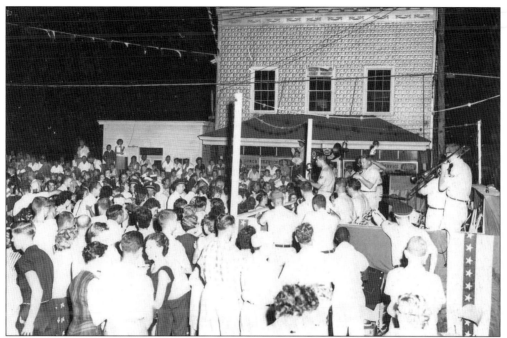

STREET DANCE. Locals filled the streets during the annual Crab Derby street dance. A live band and crowds are seen in front of the Kozy Korner on West Main Street during this early-1960s dance. Advertisements seen in the Kozy Korner's windows offer both lunch and television.

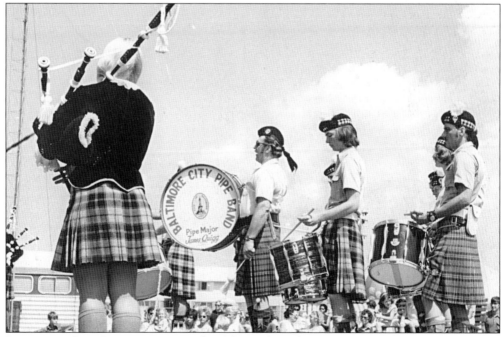

BALTIMORE CITY PIPE BAND. A staple of the Crab Derby for many years in the late 1960s and early 1970s, the Baltimore City Pipe Band performed for spectators at Somers Cove Marina during the 23rd derby in 1970. Pipe major that year was James Quigg. (Photograph by Scorchy Tawes, courtesy Crisfield Area Chamber of Commerce.)

BUILDING THE CRAB BOWL. For the 25th Crab Derby in 1972, officials decided the races should have a permanent home at Somers Cove Marina. A semi-circle of bleachers was constructed in one section of the marina's parking lot, and with the addition of the Showmobile each Labor Day weekend, that section became known as the Crab Bowl. (Photograph by Scorchy Tawes, courtesy Crisfield Area Chamber of Commerce.)

OPEN AIR RELIGIOUS SERVICE. Another long-standing part of the Crab Derby, the open air religious service, annually unites much of Crisfield's church community for a citywide Sunday morning gathering. In recent years, the ceremony sometimes has included the floating of a memorial wreath in Crisfield Harbor to honor all watermen who passed away since the previous year's derby.

SONNY JAMES AND THE SOUTHERN GENTLEMEN. Country music star Sonny James and his group, the Southern Gentlemen, celebrated the 25th Crab Derby in 1972 with a performance many still talk about in the 21st century. The entertainment grew even bigger in 1973, when singer Tammy Wynette made her only Crisfield appearance. (Photograph by Scorchy Tawes, courtesy Crisfield Area Chamber of Commerce.)

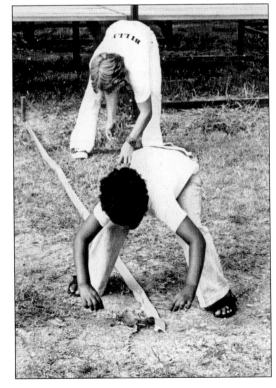

CRAB RELAY. Youngsters in the late 1970s had to watch their fingers during the crab relay contest, held for only a handful of years. Crabs are notorious for pinching—and holding onto—anything they can when they sense danger. The crab relay was revived in the mid-1990s as a challenge to local media outlets. (Photograph by Scorchy Tawes, courtesy Crisfield Area Chamber of Commerce.)

113

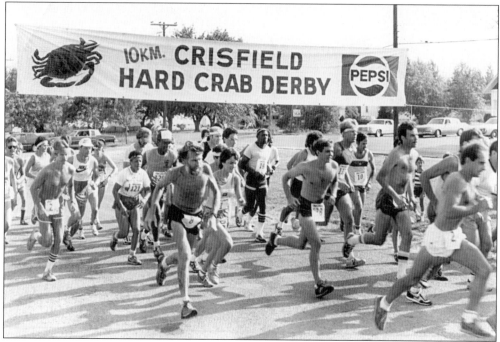

TEN-KILOMETER RACE. Seen here in the early 1980s, the Crab Derby 10K Race is another favorite annual derby event. Runner Mike Sterling has won the event so many times that in the late 1990s, the race was permanently renamed in his honor.

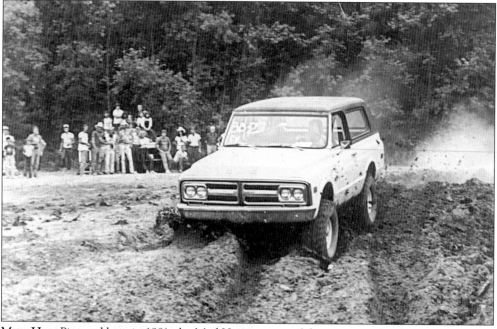

MUD HOP. Pictured here in 1981, the Mud Hop was one of the most popular derby events of the late 1970s and early 1980s. Held behind Crisfield Benevolent and Protective Order of Elks Lodge 1044, the hop featured local four-by-fours getting down and dirty. The hop died in the mid-1980s as the national four-by-four trend waned.

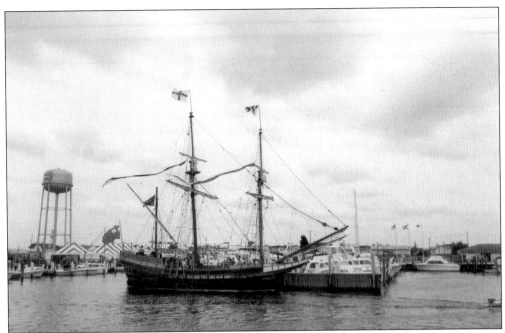

THE MARYLAND DOVE. Built in Cambridge and based in St. Mary's City, the *Maryland Dove* commemorates the 1634 trade ship *Dove*, which accompanied Lord Baltimore's original expedition to the state in the 17th century. The *Dove* docked at Somers Cove Marina for the 40th Crab Derby in 1987, offering onboard tours and a bit of ambience during that year's events.

SOFT CRAB–PACKING CONTEST. Throughout the years, derby officials have attempted to showcase nearly every segment of the seafood industry in one contest or another, from crab picking to boat docking to crab pot making. In 1991, they added another competition, albeit a short-lived one: soft crab cleaning and packing.

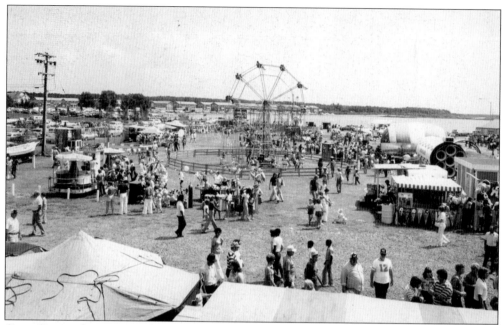

CRAB DERBY GROUNDS. For many years, the highlight for children at the Crab Derby was the Marshall Carnival, seen here at the Crab Derby grounds in 1978. Most dominant in this view is the Ferris wheel, which afforded riders an unobstructed aerial view of Crisfield Harbor. (Courtesy Crisfield Area Chamber of Commerce.)

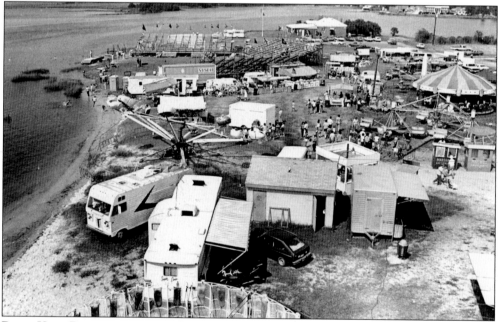

BRICK KILN. During renovations of Somers Cove Marina in the mid-1980s, the derby temporarily moved to A. Wellington Tawes Beach at Brick Kiln. Marshall Carnival rides in this view include the Octopus, Scrambler, Round-Up, and carousel. Following the Marshall Carnival's demise, Taylor and Sons Amusements provided rides at the derby, followed in recent years by Taylor's successor, Shaw Brothers Amusements. (Courtesy Crisfield Area Chamber of Commerce.)

HELICOPTERS. Jason Rhodes, author of this book, rode the Marshall Carnival's kiddie helicopters with his grandmother, Lurie Rhodes, at the 36th Crab Derby in 1983. This photograph was chosen to represent the 1980s on the cover of the 52nd Crab Derby program, which featured one photograph from each of the derby's first six decades in 1999.

SKYDIVERS. These aerial acrobats have been a part of the Crab Derby entertainment sporadically since the 1960s. Seen here in 1965, the divers drifted to Earth from the skies over Crisfield and the 18th Crab Derby festivities. (Photograph by John McIntosh, courtesy Crisfield Area Chamber of Commerce.)

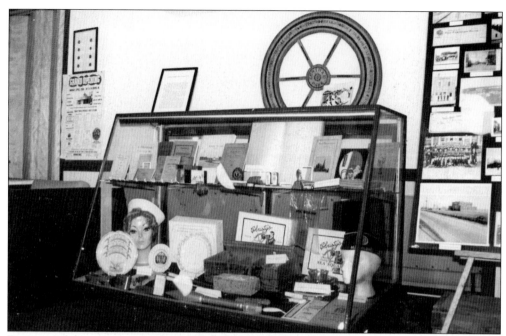

REFLECTIONS OF CRISFIELD'S PAST. Derby officials followed 1997's popular Memory Lane exhibit of Crab Derby memorabilia at the J. Millard Tawes Museum and Visitors Center with an all-Crisfield exhibit, Reflections of Crisfield's Past. Items contained in this case range from fraternal organization bylaw booklets to seafood packing boxes from local processors. The gaming wheel in the back came from Central Park, the last of the city's three amusement parks, once located on Main Street Extended.

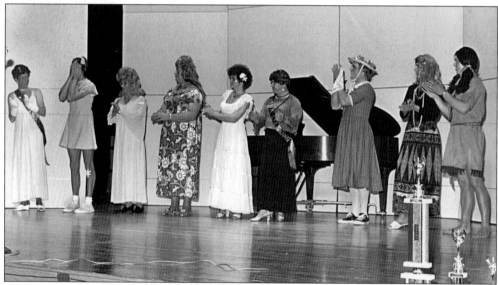

Ms. CRAB CLAW CONTESTANTS. Perhaps the most unusual contest associated with the Crab Derby, the Ms. Crab Claw Pageant, actually served as an anti-beauty pageant in the late 1970s and early 1980s. Men dressed in drag and used stage names to compete for the dubious title. The winner of the 1979 pageant was "Minnie Pearl," seen to the right of the piano. (Photograph by Scorchy Tawes, courtesy Crisfield Area Chamber of Commerce.)

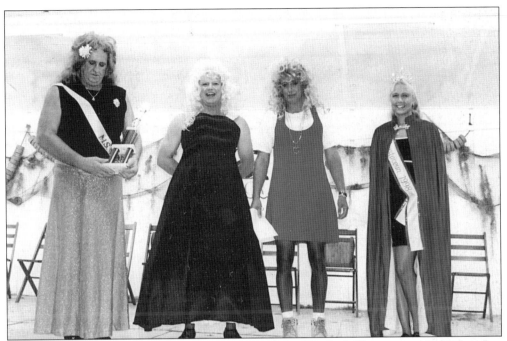

MS. CRAB CLAW 1998. Derby officials brought back the Ms. Crab Claw pageant in 1998, giving a new generation a chance to dress in drag for entertainment's sake. Pictured from left to right are Ms. Crab Claw 1998 Gorman Abbott, Robbie Gunter, Jamie Gragg, and Miss Crustacean 1998 Tanya Briddell.

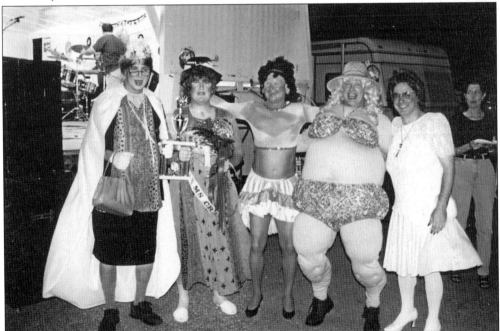

MS. CRAB CLAW 1999. Crisfield saw its first shared Ms. Crab Claw title in 1999, when Willis Dryden and Erik Emely entered the pageant as a duo. Pictured from left to right are Dryden, Emely, Guy Marshall, Robbie Gunter, and Danny Thompson.

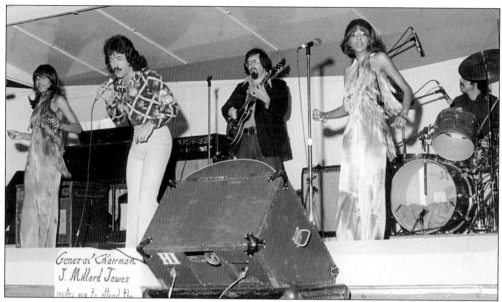

TONY ORLANDO AND DAWN. Throughout the years, derby officials have held a multitude of fund-raisers for the annual event. In 1973, singer Tony Orlando and his group, Dawn, performed a benefit concert in Crisfield during the months prior to the derby. That year's event chairman, J. Millard Tawes, welcomed concert attendees to that year's 26th Crab Derby with a sign on the front of the Showmobile stage. (Photograph by Scorchy Tawes, courtesy Crisfield Area Chamber of Commerce.)

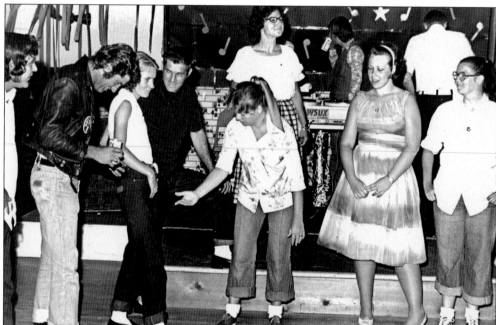

GREASER NIGHT. *Happy Days* was one of the most popular shows on television when Crisfield reverted back to the 1950s with this Greaser Night fund-raiser for the 30th Crab Derby. Local residents dressed in their best blue jeans, poodle skirts, and leather jackets for the occasion. (Photograph by Scorchy Tawes, courtesy Crisfield Area Chamber of Commerce.)

Nine

GOLDEN ANNIVERSARY

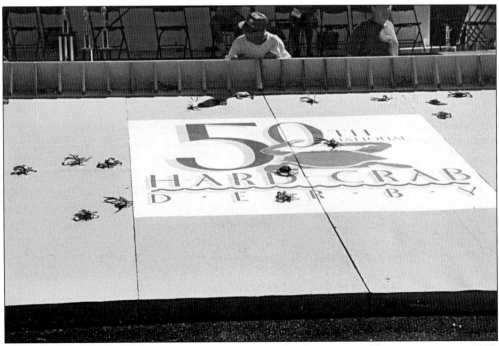

NEW LOGO. Crab Derby officials unveiled a new logo for the event's golden anniversary in 1997. Seen here on the Crab Cake Track during the 50th crab races, the blue-and-pink design, minus the "50th" has served as the derby's official logo into the 21st century.

SHADOWS OF TIME. Miss Crustaceans from 1951 to 1996 gathered on the Crisfield High School auditorium stage to kick off the 1997 Miss Crustacean Pageant, featuring the theme Shadows of Time. The reunion marked the largest such event in the derby's history.

PAST, PRESENT, AND FUTURE. Miss America 1963 Jacquelyn Mayer returned to Crisfield for the first time in more than three decades to help celebrate the 50th Crab Derby. Pictured from left to right at that year's Miss Crustacean Pageant are Mrs. Maryland 1997, Miss Crustacean 1997 Sara Widdowson, and Mayer.

LITTLE MISS AND MR. CRUSTACEAN. Little Miss Crustacean 1997 Whitney Marshall and Little Mr. Crustacean 1997 Andy Brice (both center) posed with their court on stage following that year's pageant. The contest centered on a baseball theme, with a special guest appearance by the Baltimore Orioles' mascot, the Oriole Bird.

MAIN GATE. Though a week's worth of activities highlighted the 50th Crab Derby, the highlight was still the opening of the Crab Bowl at Somers Cove Marina on Labor Day weekend. For the only time in the derby's history, this special gate greeted visitors as they entered the derby grounds.

123

MEMORY LANE. Held at the J. Millard Tawes Museum and Visitors Center for one weekend only, the Memory Lane exhibit featured photographs, programs, and other artifacts from half a century of the Crab Derby. The boat parade display, seen here, featured two of the plywood crabs from the *A Go-Go*, along with an original flag from the *Chester Peake*.

MORE MEMORIES. Memorabilia from the Chesapeake Bay Fishing Fair, Crab Derby trophies and other items filled this display case at the Memory Lane exhibit. The yellow vest and derby in the middle were the type worn by the Crisfield Jaycees during their many years hosting derby events. This particular vest belonged to Jaycee Donnie Drewer.

CRAB TOPIARY. This crabby plant served a dual purpose, originally used as a decoration at the Crabbers Ball. The traditional Crab Derby dance, missing from derby festivities for a decade, was reinstated for the 50th anniversary. Following the dance, it moved to the location in Somers Cove Marina, seen here, to highlight the entrance to the Taste of Crisfield tent.

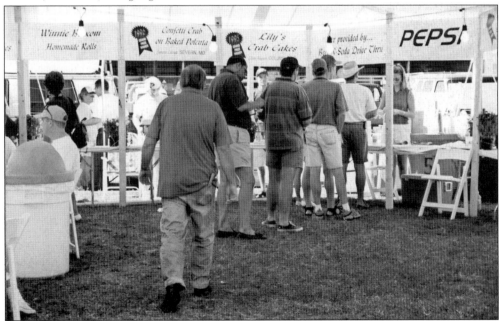

A TASTE OF CRISFIELD. An event held exclusively for the 50th anniversary, a Taste of Crisfield allowed ticket holders to sample crab dishes prepared from past winning crab cooking contest recipes. Signature side dishes provided by local cooks and restaurants complemented the experience. Tickets to the food booths beneath the tent cost $1 per taste.

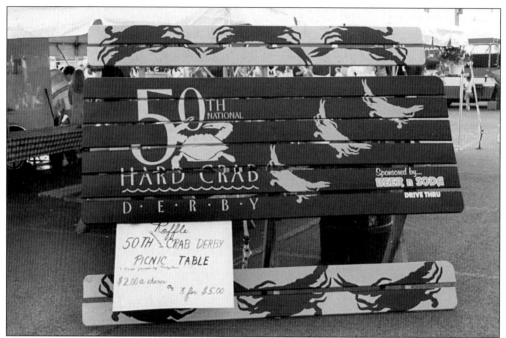

CRAB DERBY RAFFLE. Derby officials promoted the event's new logo with this one-of-a-kind picnic table. The green and yellow table (a departure from the logo's more traditional blue and pink colors) was raffled off as a unique souvenir offered for the golden anniversary. Beer 'n' Soda Drive-Thru of Crisfield sponsored the raffle.

KENT COUNTY CRAB. This mascot of the Kent County Community Marching Band of Rock Hall, Maryland, proved to be the perfect complement to the 50th Crab Derby. The Kent County band made its Crisfield debut in 1997 and has become a mainstay of the Main Street Parade in the 21st century.

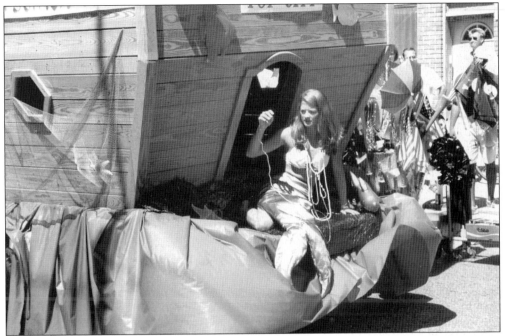

TROPICAL CHESAPEAKE. In a year that brought out the best from local float builders, one of the most ornate was this entry from the Tropical Chesapeake restaurant. Buccaneers aboard the wooden pirate ship, featuring this mermaid on the back, took the tradition of throwing out candy to children in the audience a step further, passing out something more useful that hot Labor Day weekend: sunscreen samples.

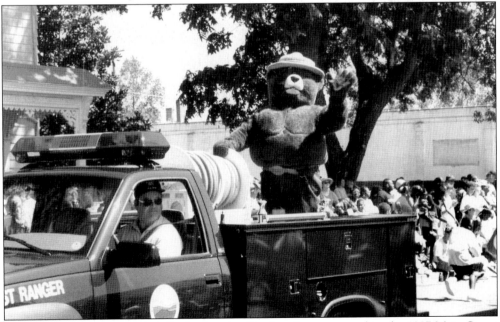

SMOKEY BEAR. Another Crab Derby favorite, Smokey Bear appeared in the 1997 Main Street Parade courtesy of the Maryland Department of Natural Resources and Janes Island State Park. Smokey waved as he passed the reviewing stand, placed that year next to city hall.

CRABS ALL AROUND. This 50th anniversary float may have been the crabbiest at that year's parade. In addition to the three large crabs visible in this shot, the float's nautical theme extended to include seaweed made from green streamers, white balloon bubbles, and even a discarded crab pot, seen near the truck's tailgate.

LITTLE LEAGUE CHAMPIONS. The Crisfield Little League's 9- and 10-year-old team made history in 1997, winning the Maryland District 8 championship. It seemed only fitting to honor the players with their own Main Street Parade float. The baseball theme fit in quite well considering that year's parade grand marshal was former Baltimore Orioles outfielder Al Bumbry.